Bunny Yeager's
Flirts of the

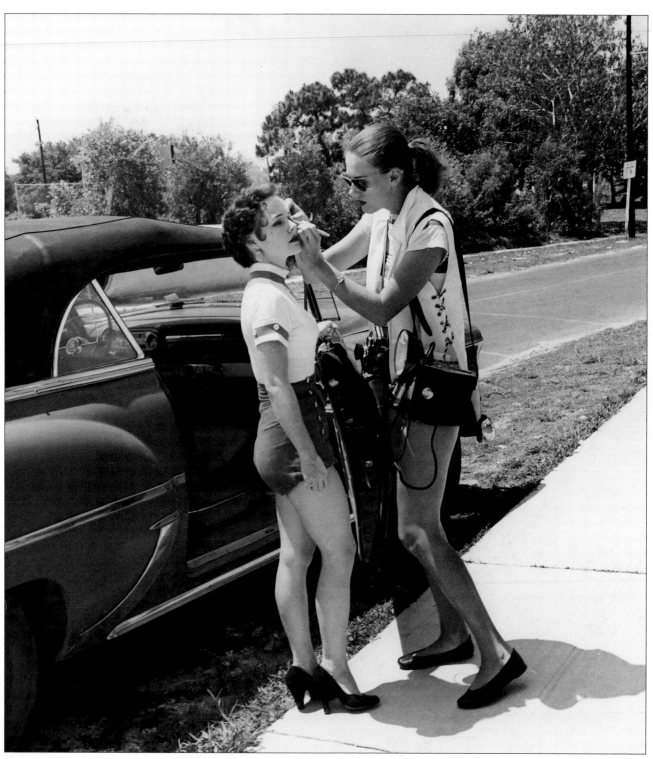

Schiffer Publishing Ltd

4880 LOWER VALLEY ROAD ATGLEN, PENNSYLVANIA 19310

Other books by Bunny Yeager

Photographing Girls in Jamaica
Bunny's Bikini Beauties
Bunny's Honeys
Bettie Page Confidential
How I Photograph Nudes
How I Photograph Myself
100 Girls
Camera in the Caribbean
Camera in Mexico
Camera in Jamaica
Bunny Yeager's New Photo Discoveries
Bunny Yeager's Famous Models
Fifty New Models
How to Take Figure Photos
Bunny Yeager's Photo Studies

How to Photograph the Figure
ABC's of Figure Photography
The Art of Glamour Photography
Photographing the Female Figure
Drawing the Human Figure Using Photographs
Bunny Yeager's Postcard Book
Bunny Yeager's Bikini Girls of the 1950s
Bikini Girls of the 1960s
Bunny Yeager's Pin-Up Girls of the 1950s
Bunny Yeager's Pin-Up Girls of the 1960s

For information about ordering photographs by Bunny Yeager, write to her at 9301 NE 6 Avenue, Suite B201, Miami, FL 33138 or at bunnyyeager@aol.com. Her telephone number is 305-757-8978. Visit her website at bunnyyeager.com.

Cover photo:
Cover girl is Maria Stinger, known as Miami's Marilyn Monroe. When the movie Seven Year Itch was released, the theater promoted it by having a "look-alike" beauty contest. Maria won it.

Title page photo:
Bunny Yeager applies make-up to Carolyn Kelly before shooting on location. See Carolyn in action on page 89.

Designed by John P. Cheek
Cover design by Bruce Waters
Type set in Korinna BT

ISBN: 978-0-7643-2637-0
Printed in China

Published by Schiffer Publishing Ltd.
4880 Lower Valley Road
Atglen, PA 19310
Phone: (610) 593-1777; Fax: (610) 593-2002
E-mail: Info@schifferbooks.com

For the largest selection of fine reference books on this and related subjects, please visit our web site at
www.schifferbooks.com
We are always looking for people to write books on new and related subjects. If you have an idea for a book please contact us at the above address.

This book may be purchased from the publisher.
Include $3.95 for shipping.
Please try your bookstore first.
You may write for a free catalog.

In Europe, Schiffer books are distributed by
Bushwood Books
6 Marksbury Ave.
Kew Gardens
Surrey TW9 4JF England
Phone: 44 (0) 20 8392-8585;
Fax: 44 (0) 20 8392-9876
E-mail: info@bushwoodbooks.co.uk
Website: www.bushwoodbooks.co.uk
Free postage in the U.K., Europe; air mail at cost.

Bunny Yeager,
Photographer and Model

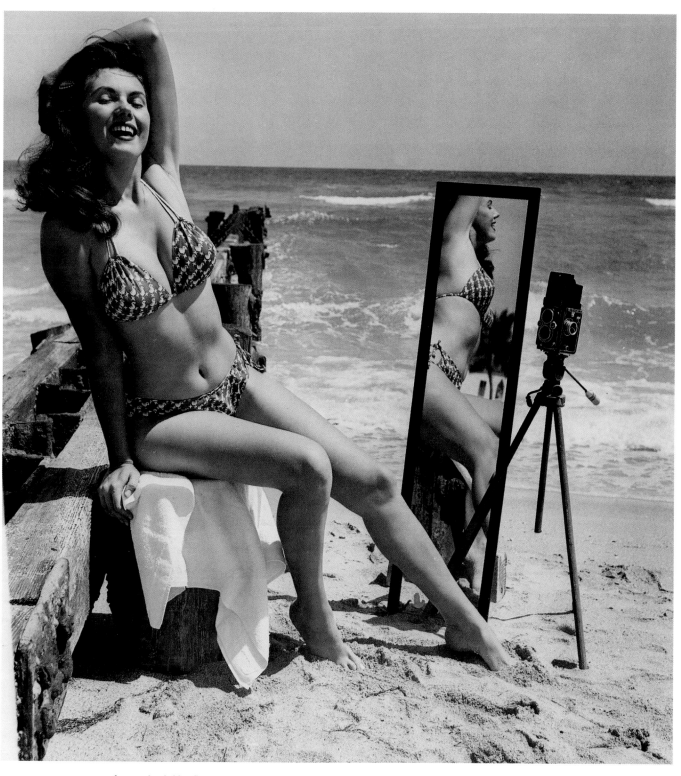

It may look like flirting when Bunny sets up her camera on a tripod with a mirror beside it
while she goes into various posing positions to take her own photo but she is not. She has
careully selected a location where there is no one around. (Unless it is a "peeping Tom"!)

Contents

Introduction
Tina Skinner

Bunny Yeager's name is synonymous with the glamorous, playful pin-up girls of the 1950s. She worked both ends of the camera, launching her career as a beauty queen and model, and then taking control of the shutter to become one of America's best-known photographers.

As a beauty contestant, her achievements included the crown of Miami Sports Queen in 1949, with a trophy presented by baseball star Joe DiMaggio. She went on to become one of the most popular Florida pin-up models of the 1950s, and appeared in Playboy. It wasn't long, however, before she started creating her own celebrities. Her subjects included Bettie Page, and Yeager's work was greatly responsible for that that pop icon's success.

Yeager was proclaimed "The World's Prettiest Photographer" in 1953 by U.S. Camera magazine, and in

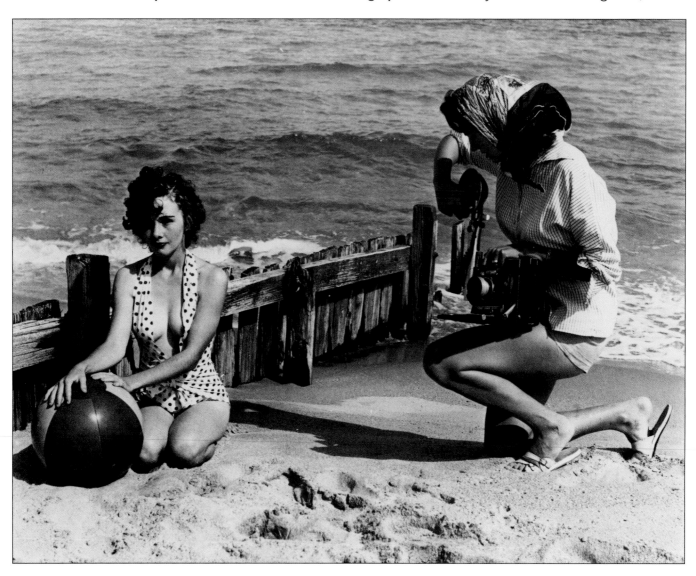

Bunny working with Mary Poole on beach

1959 she was chosen as Photographer of the Year. She has published numerous books of her photographs.

Recently, Yeager was featured in a CNN story about the 60th anniversary of the bikini. Her many talents include sewing, and she often created the bikinis her subjects modeled for photographs.

Yeager was at her best photographing full-figured women cavorting in the Florida sun. Her dramatic settings often involve the surf and sand of her hometown, Miami. And her early work is evocative of an era of flirtatious innocence. This book explores the themes of "flirty" and "fifties" as they came to symbolize femininity in the midst of the 20th century.

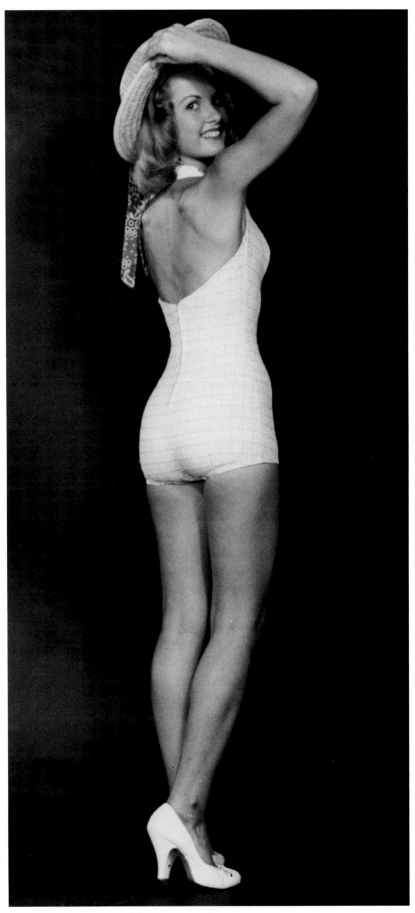

Alice Lightbourne

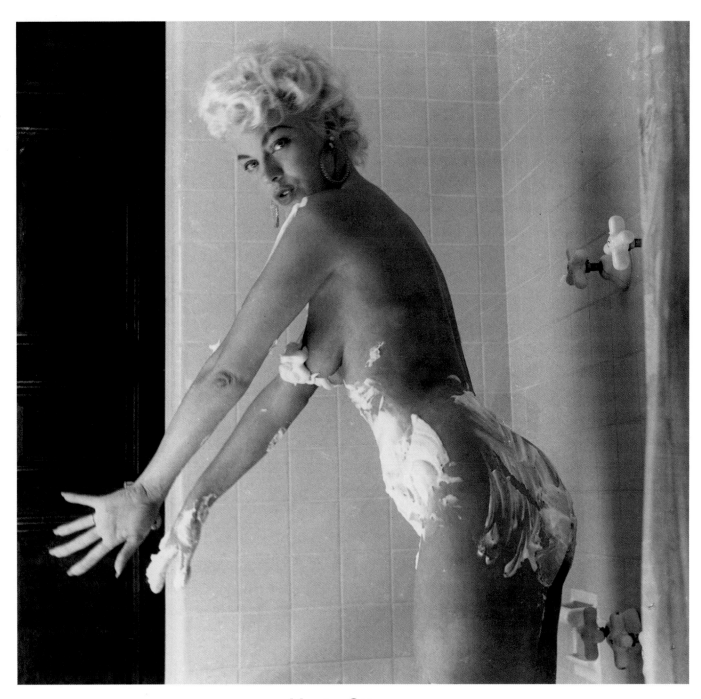

Maria Stinger

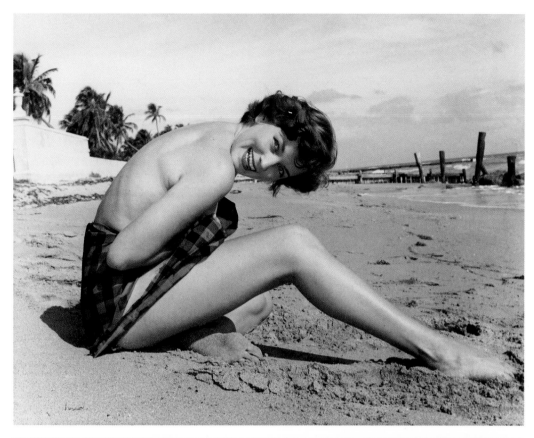

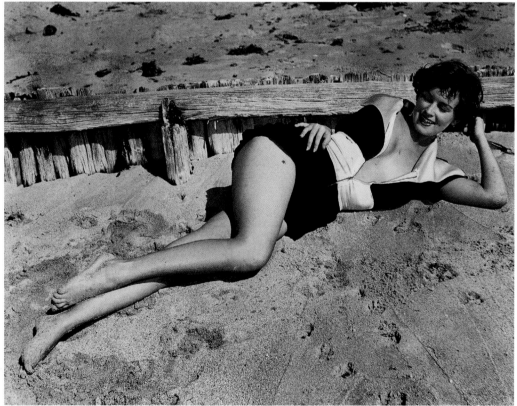

Lana Bashama

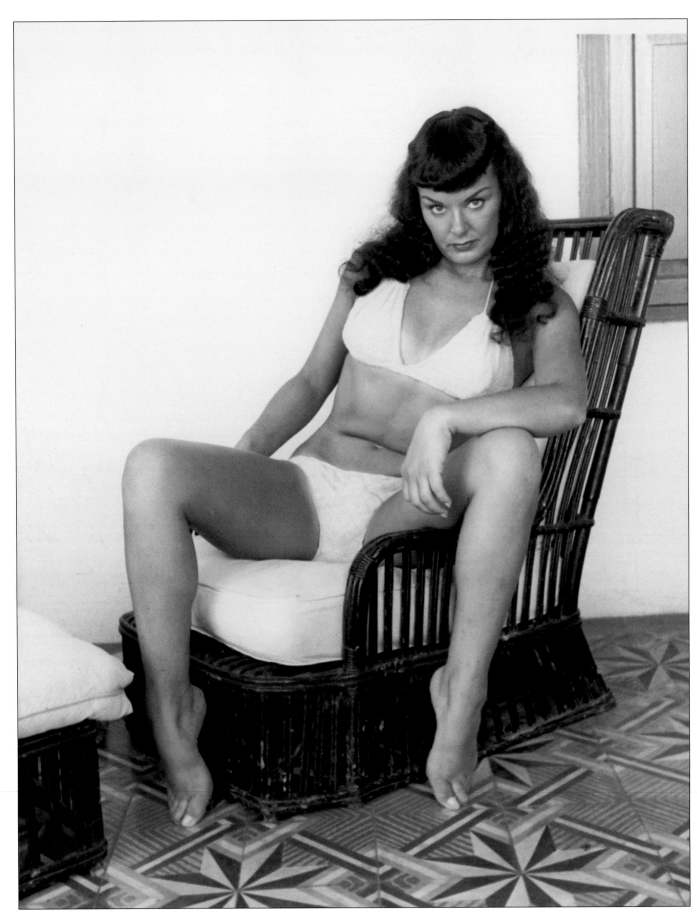

Dolly Doyle

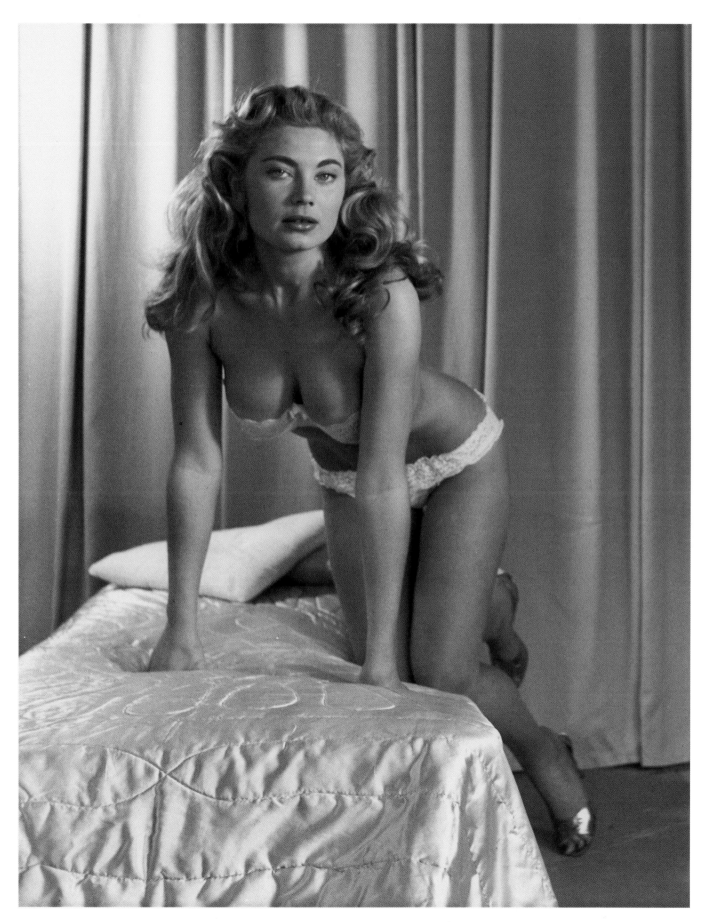

Nadine Ducas

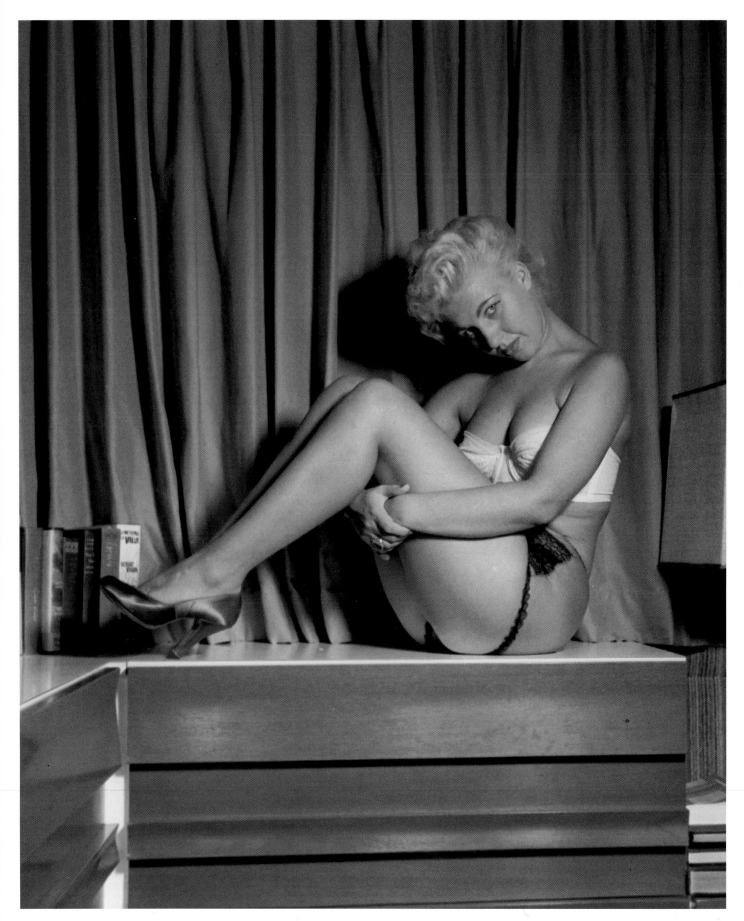

Una Diehl

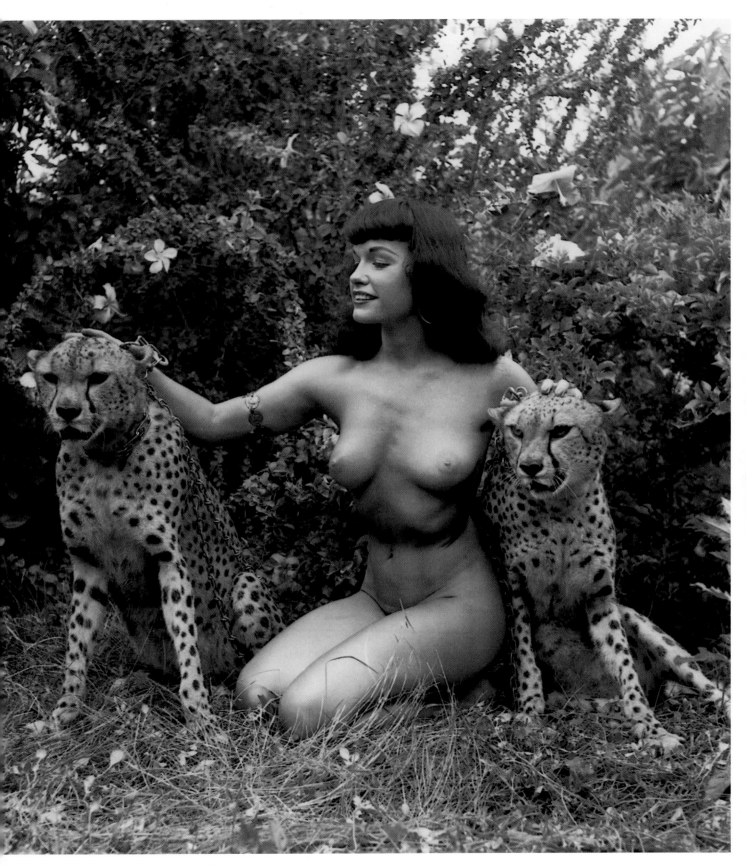

Bettie Page

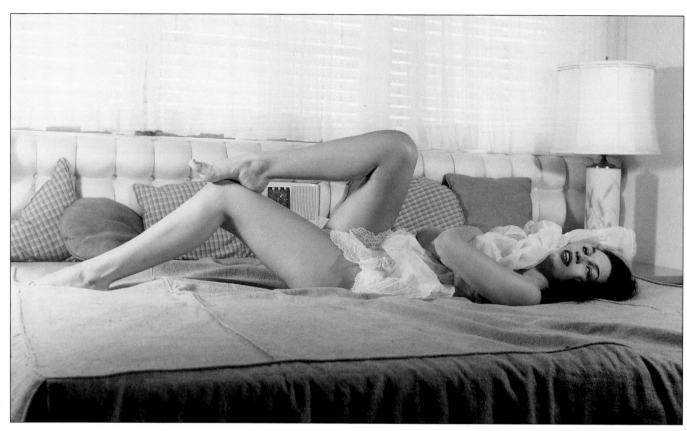

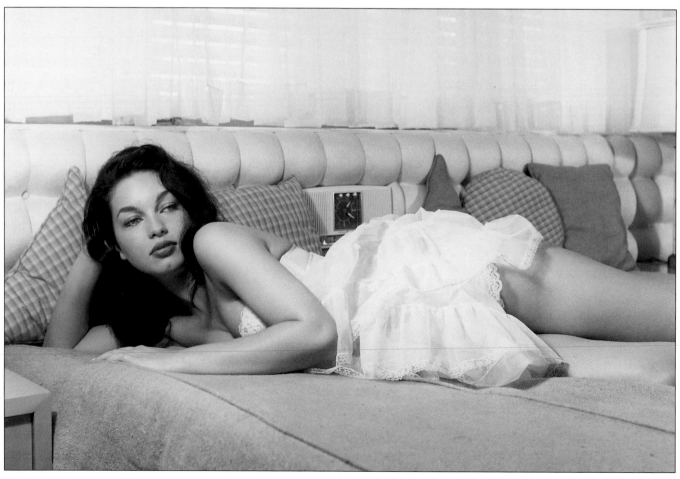

Linda Vargas

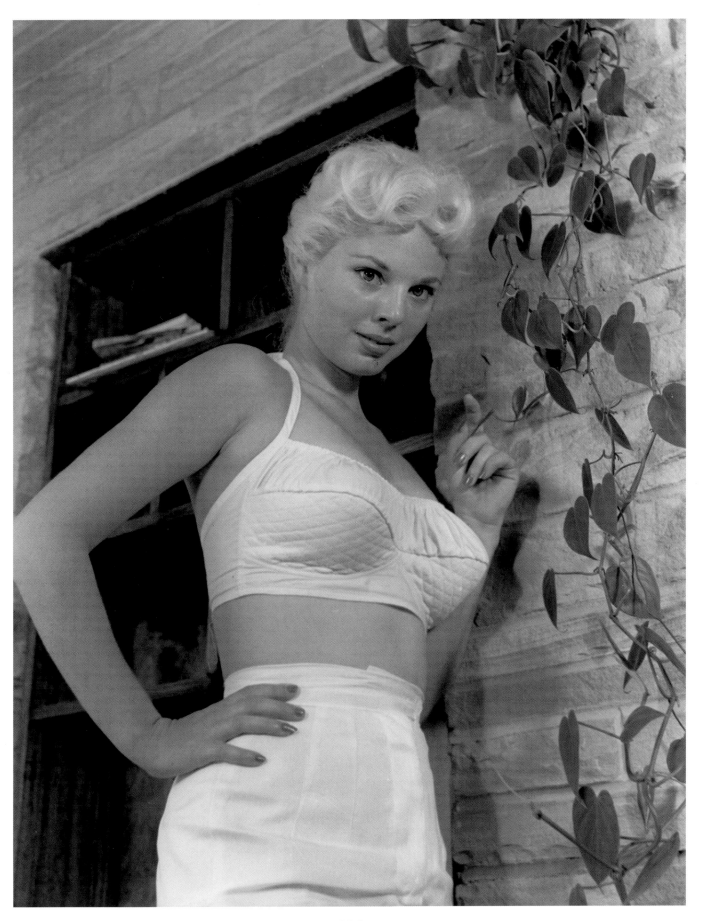

Lisa Winters

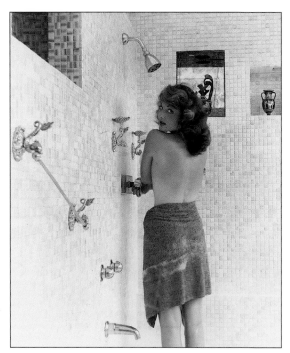
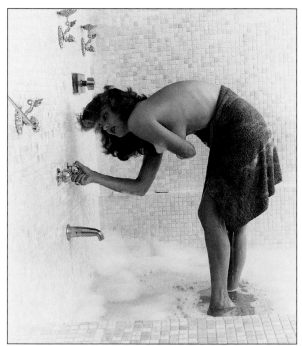
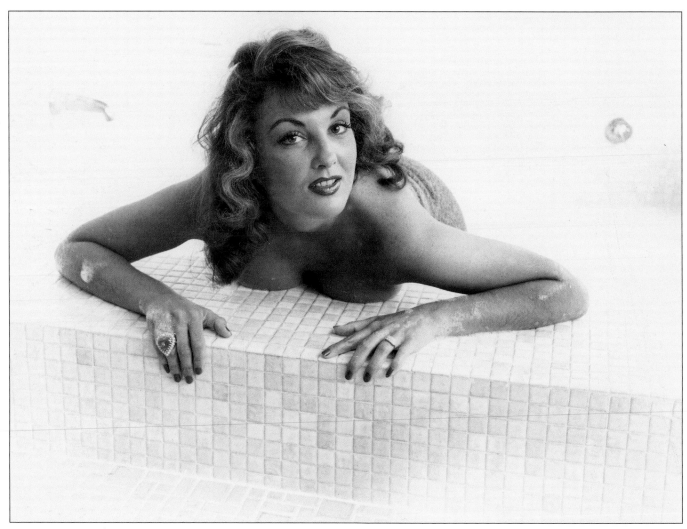

Allison Hayes

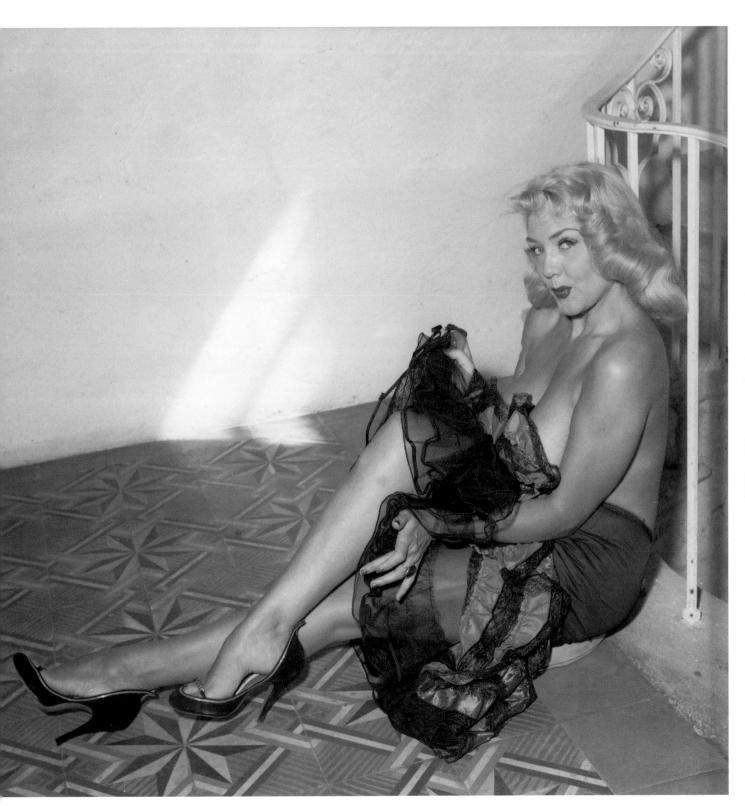

Jenny Lee

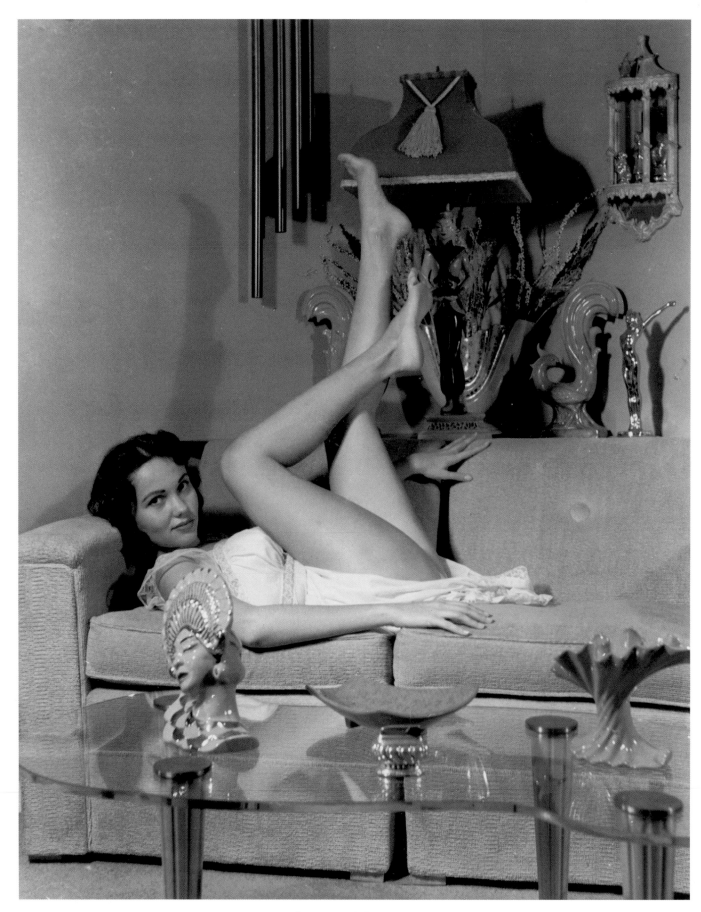

Joyce Nizzari

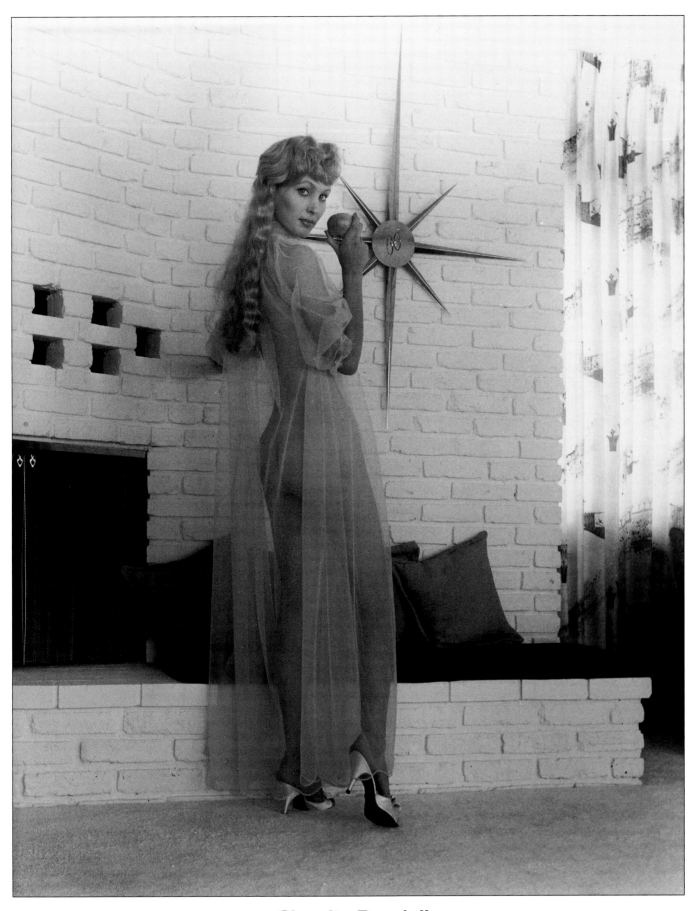

Claudia Randall

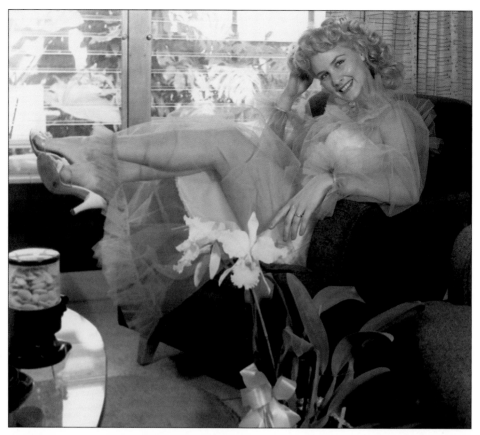

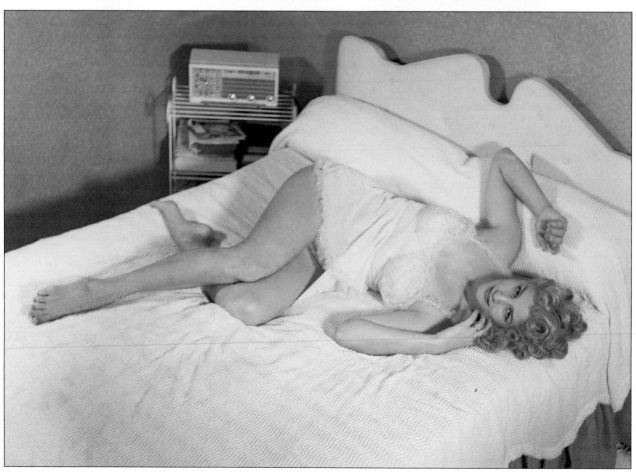

Kathleen Stanley

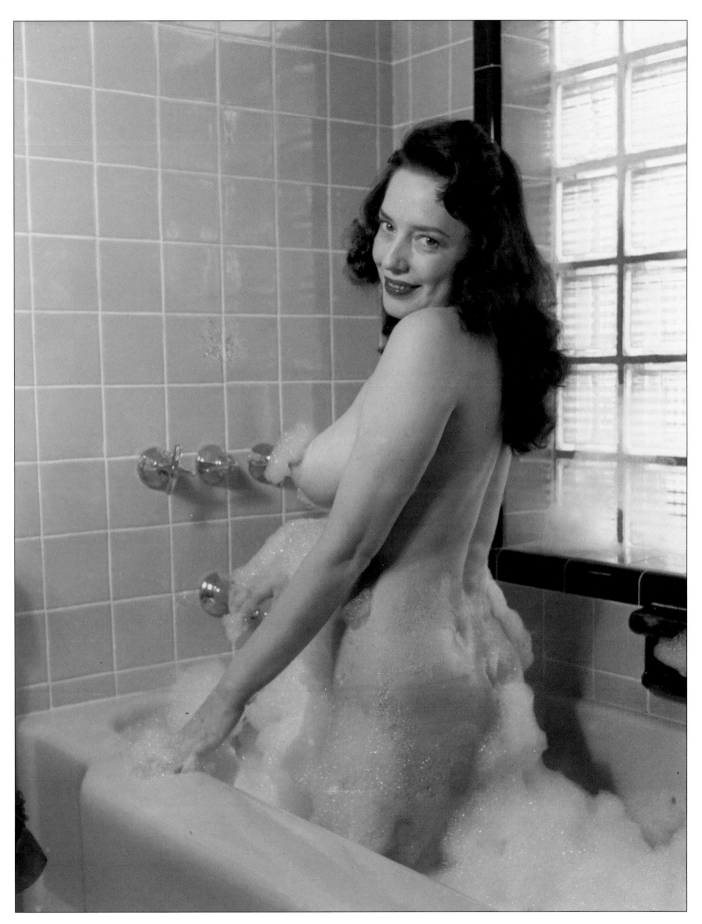

Evelyn West

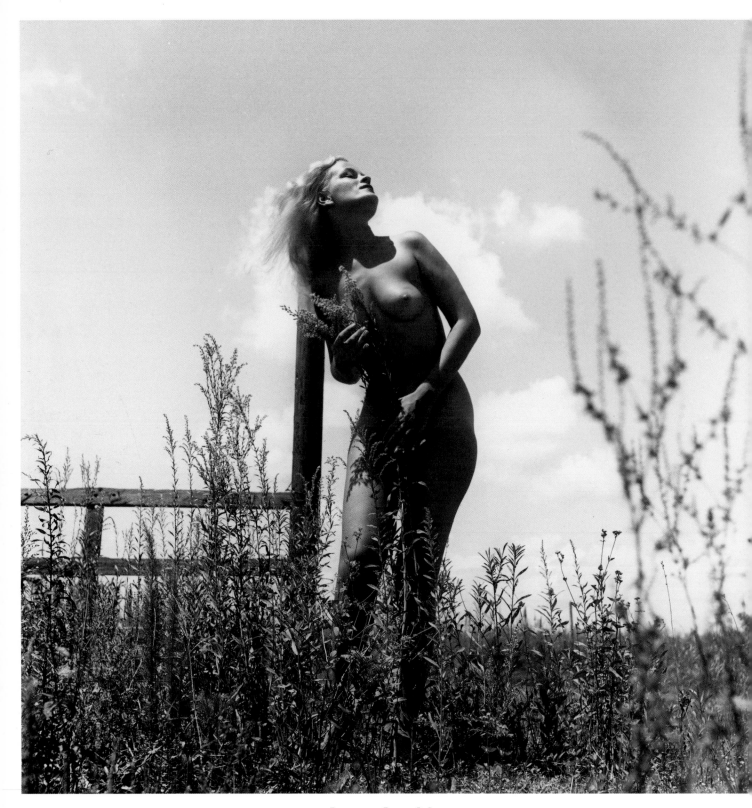

Lynn Lyckles

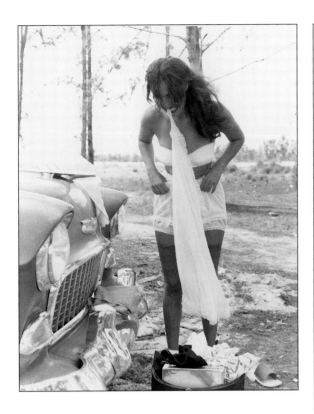

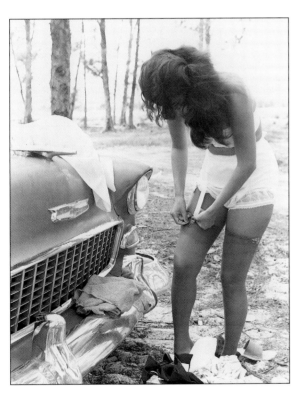

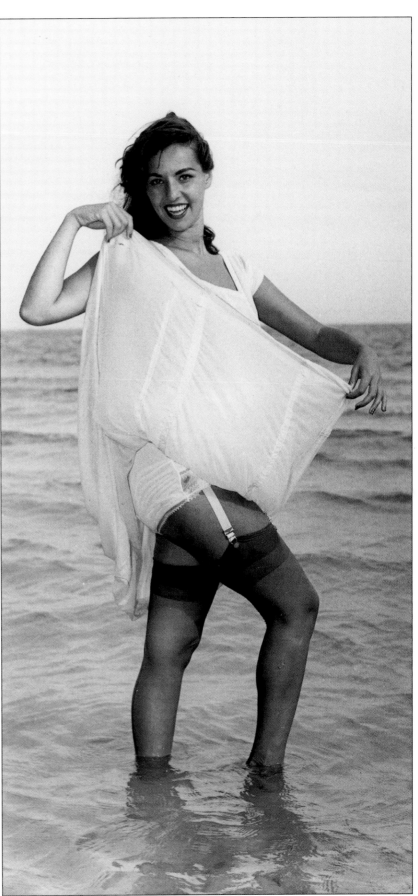

Cindy Fuller

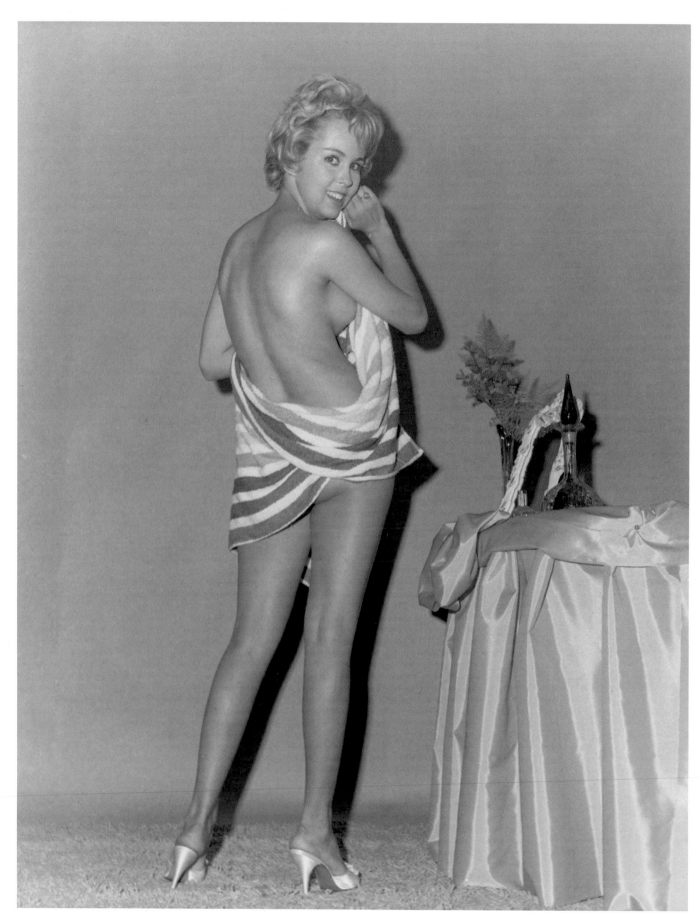

Tammy Edwards

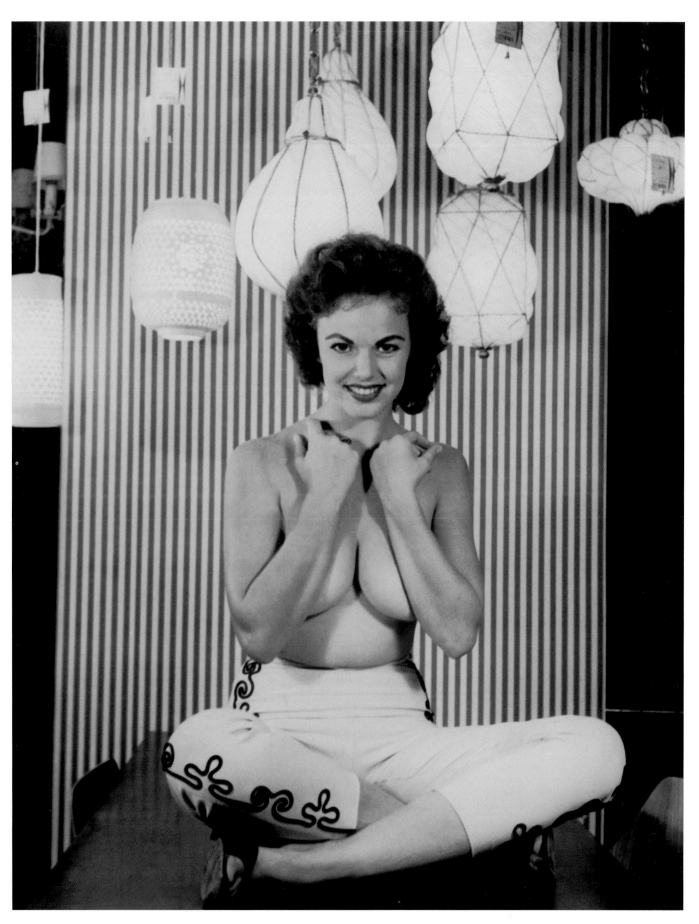

Myrna Weber

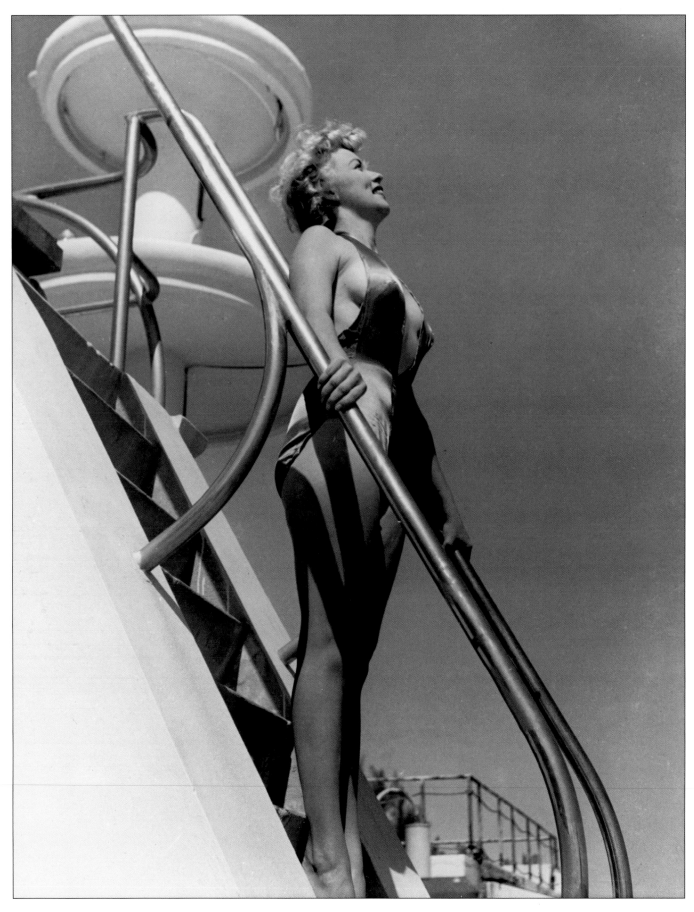

Elaine Beatty

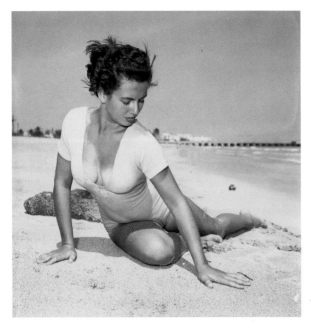

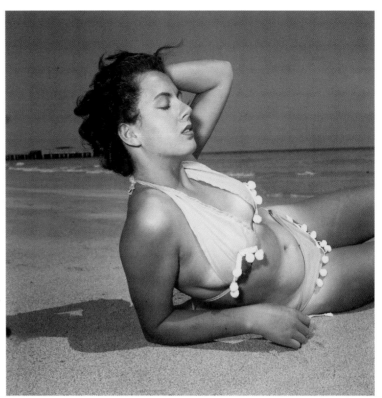

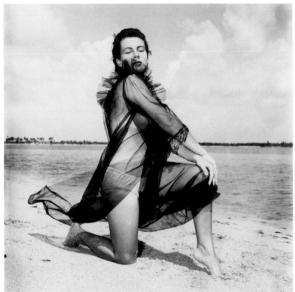

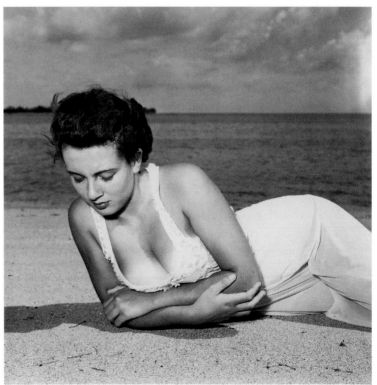

Lynn Brooks

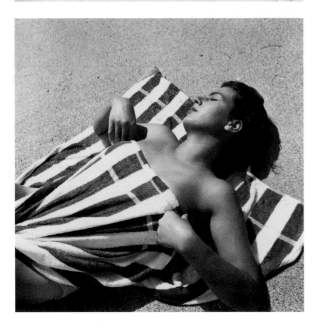

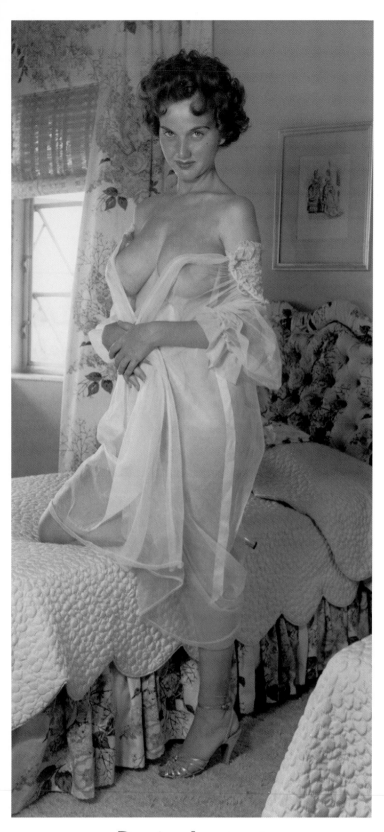

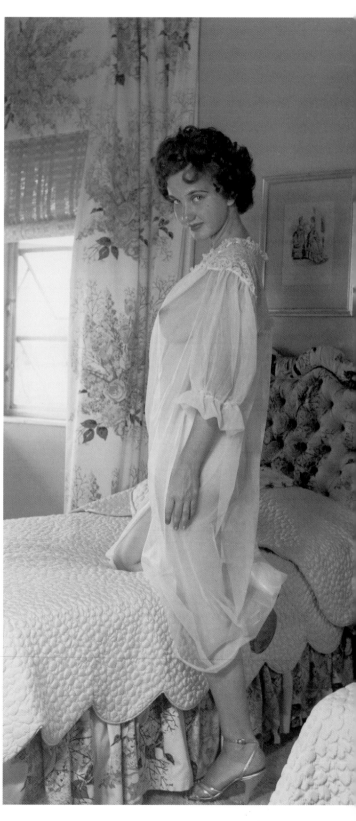

Denise Lamont

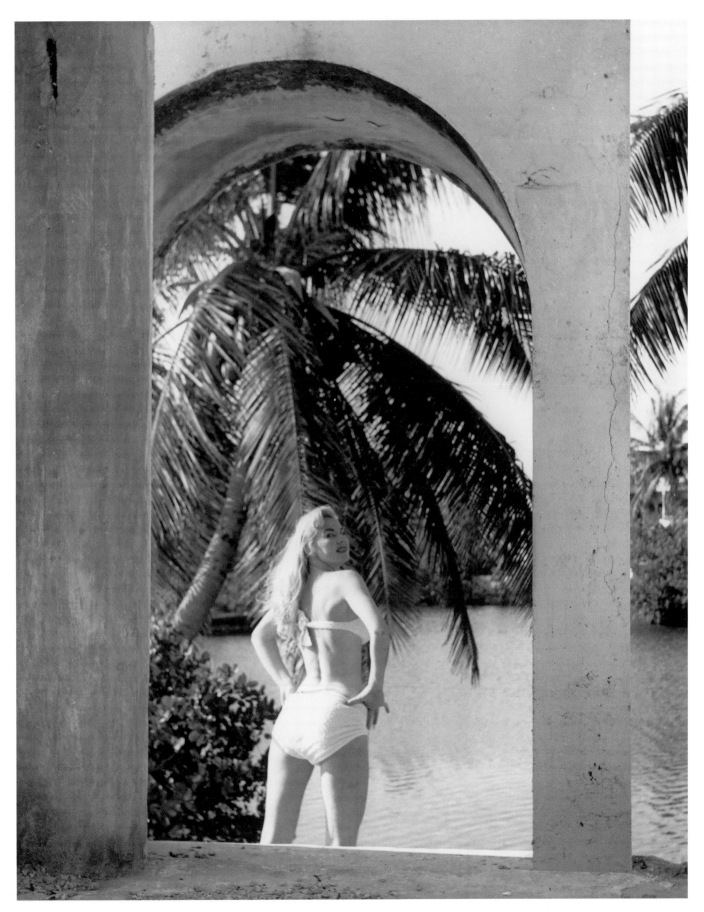

Candy Tint

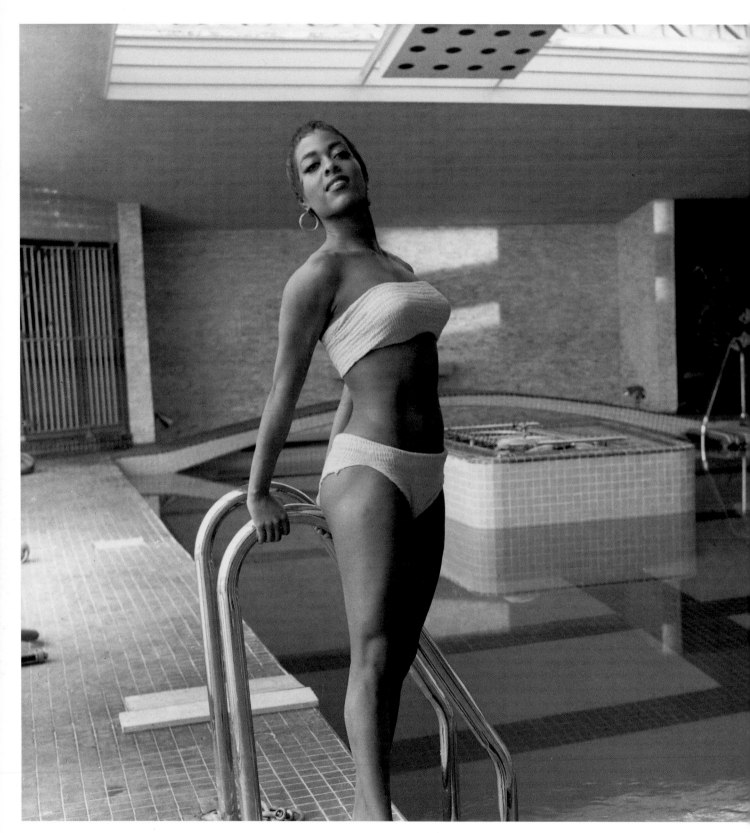

La Raine Meeres

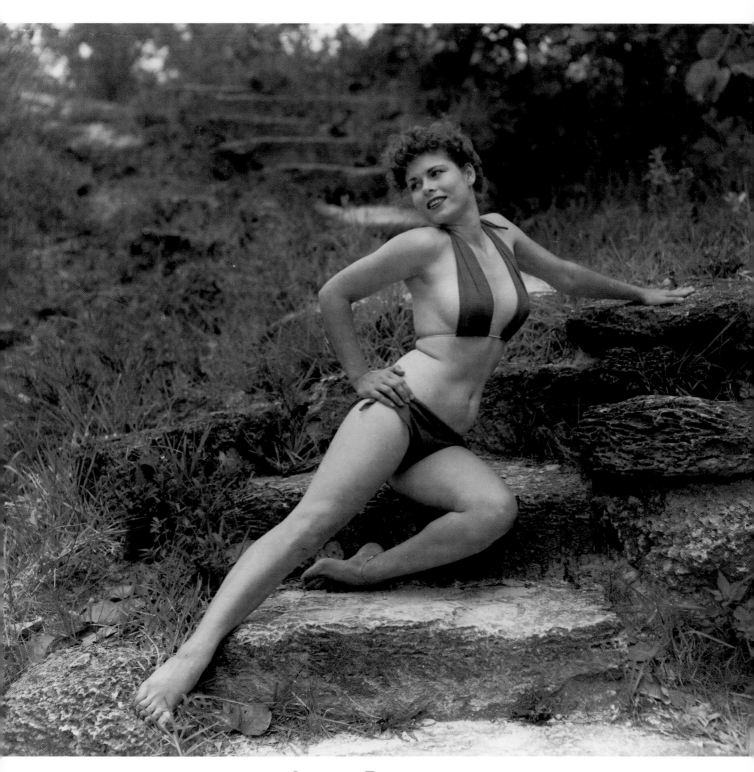

Louise Rogers

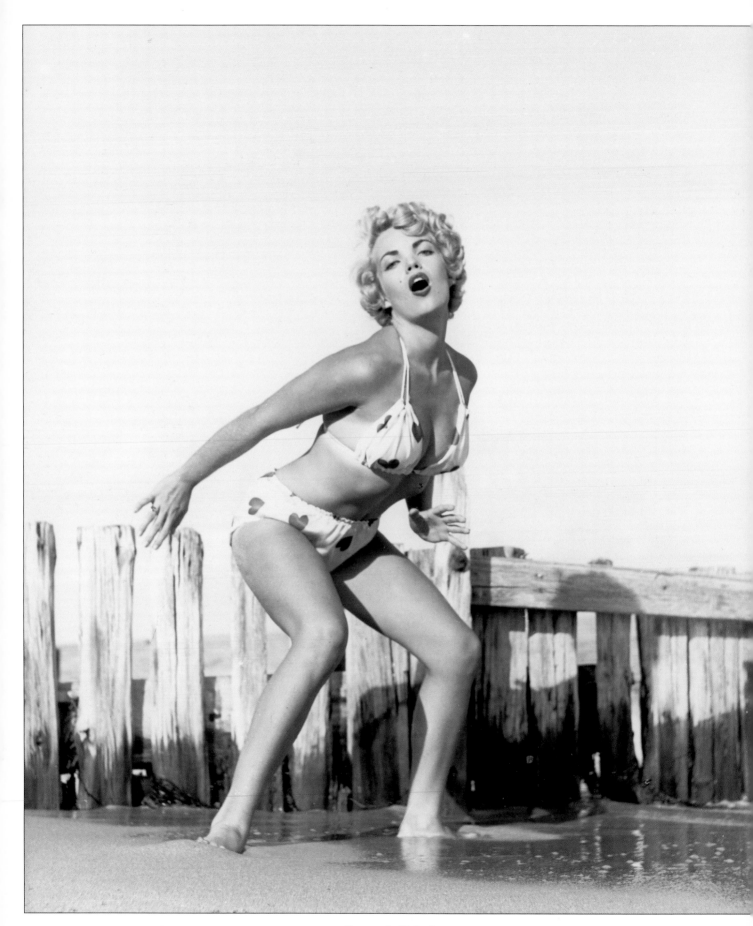

Carol Blake

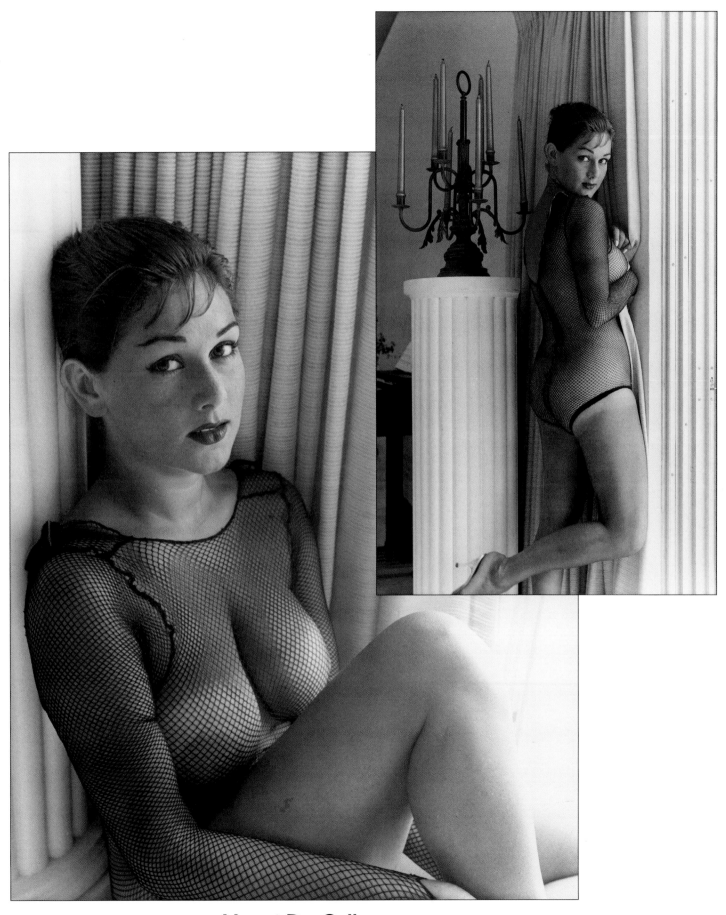

Nanci De Celle

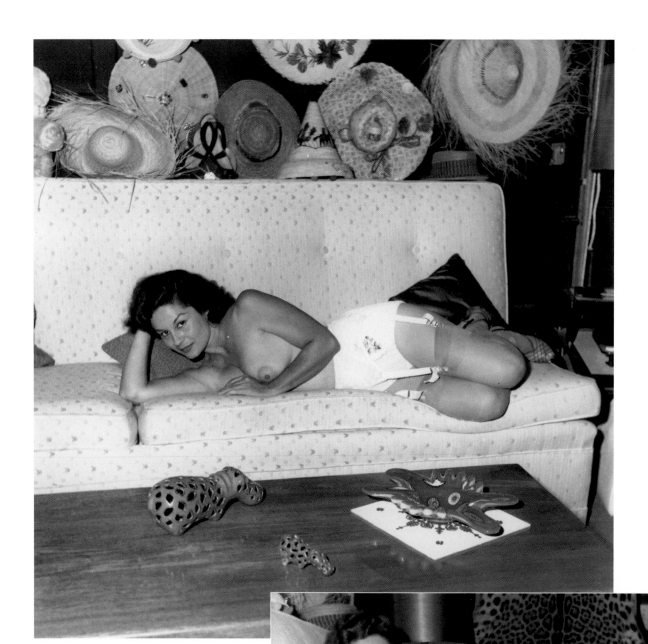

Dolores Carlos

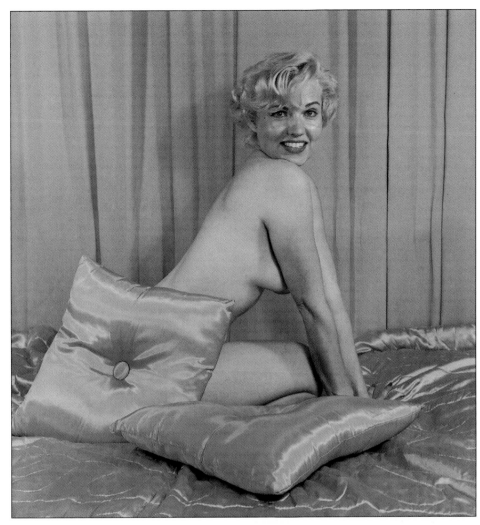

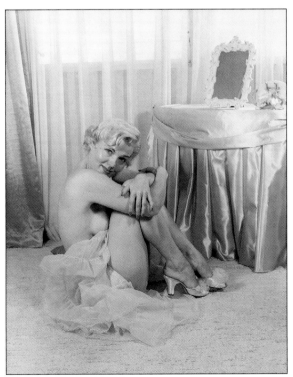 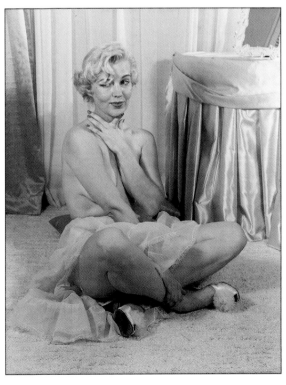

Virginia Booker

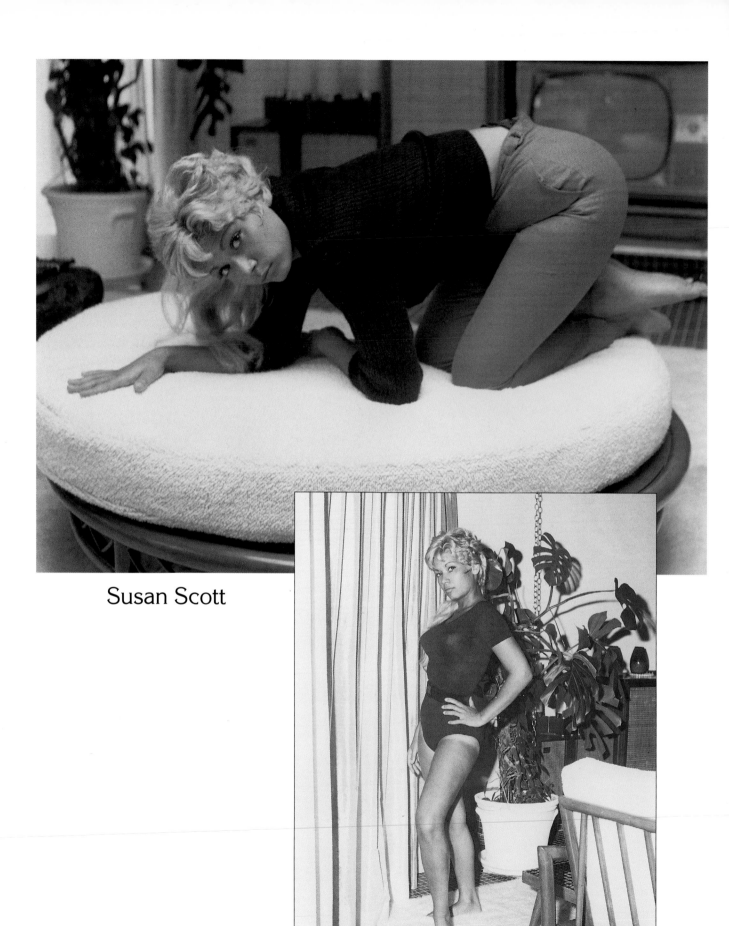

Susan Scott

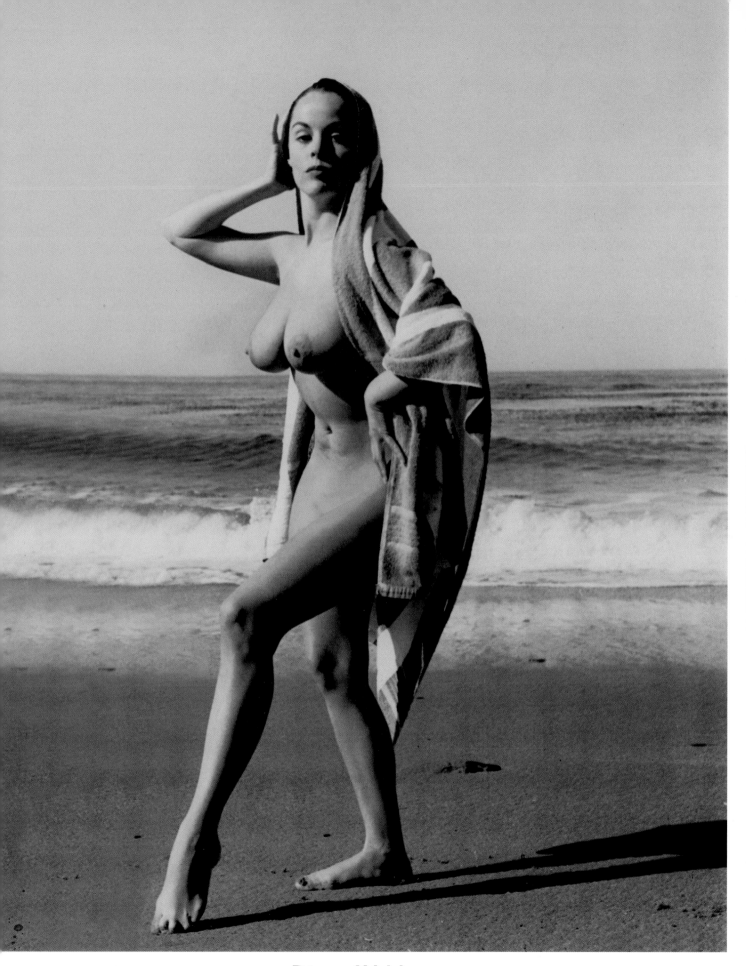

Diane Webber

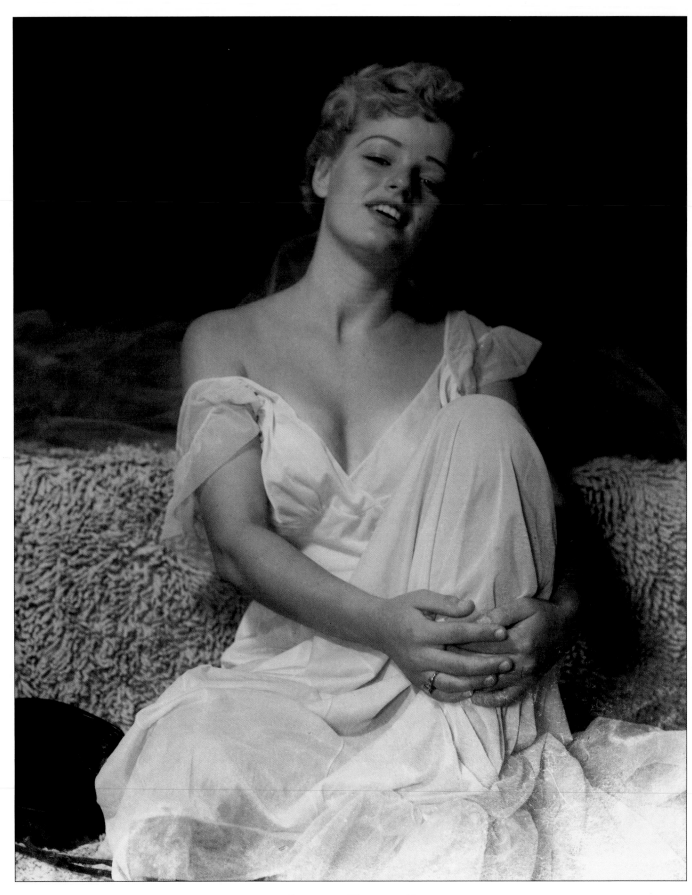

Joyce Russell

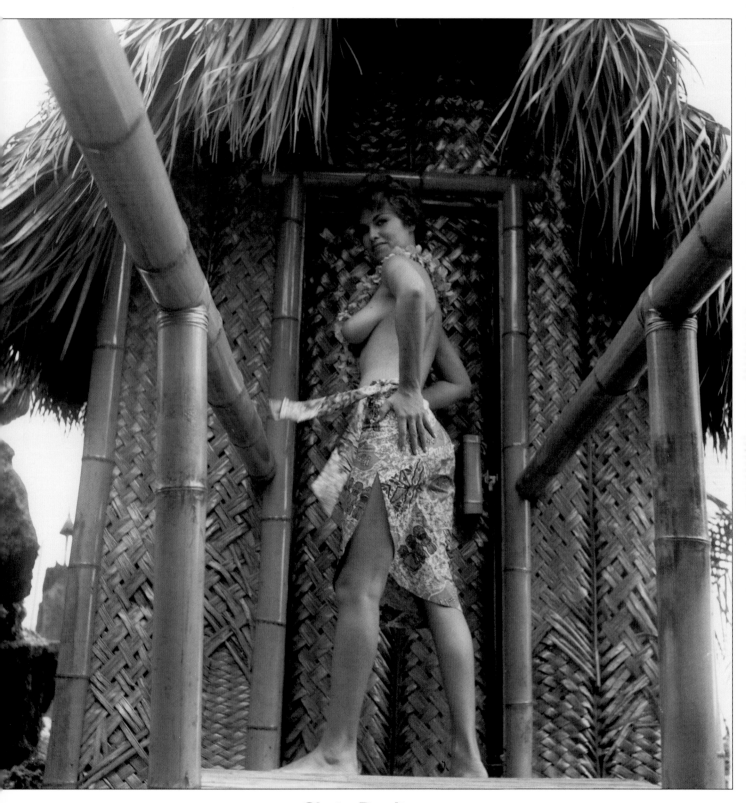

Chris Darling

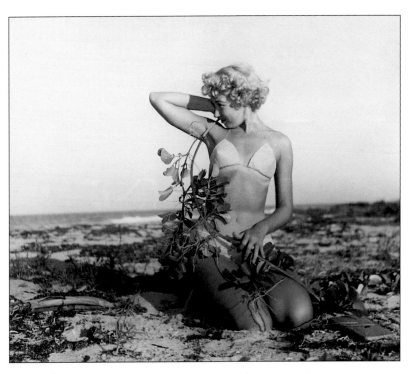

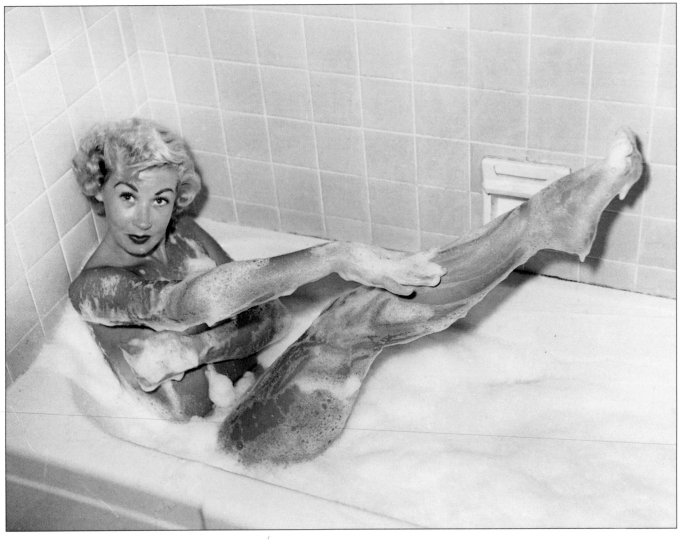

Pat Stanford

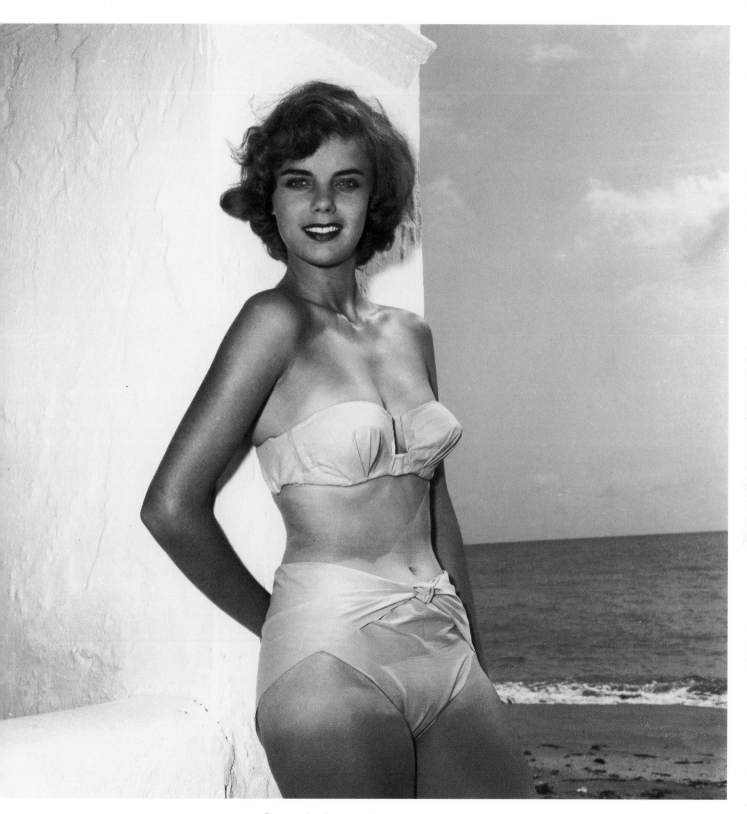

Carol Jean Lauritzen

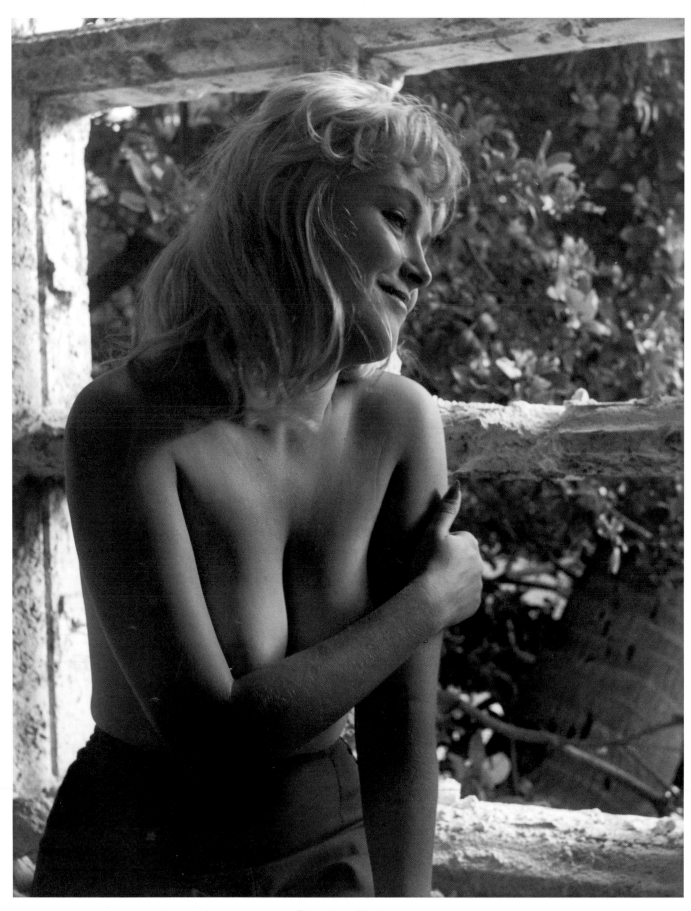

Carrie Price

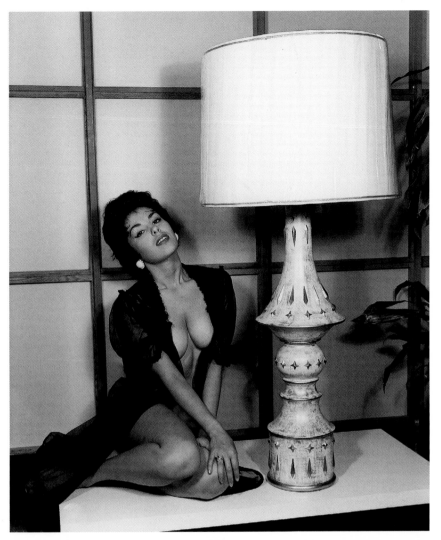

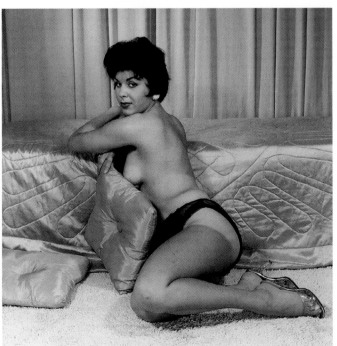
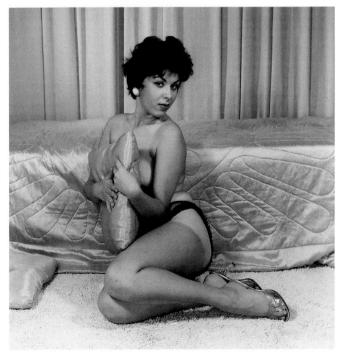

Nina Coral

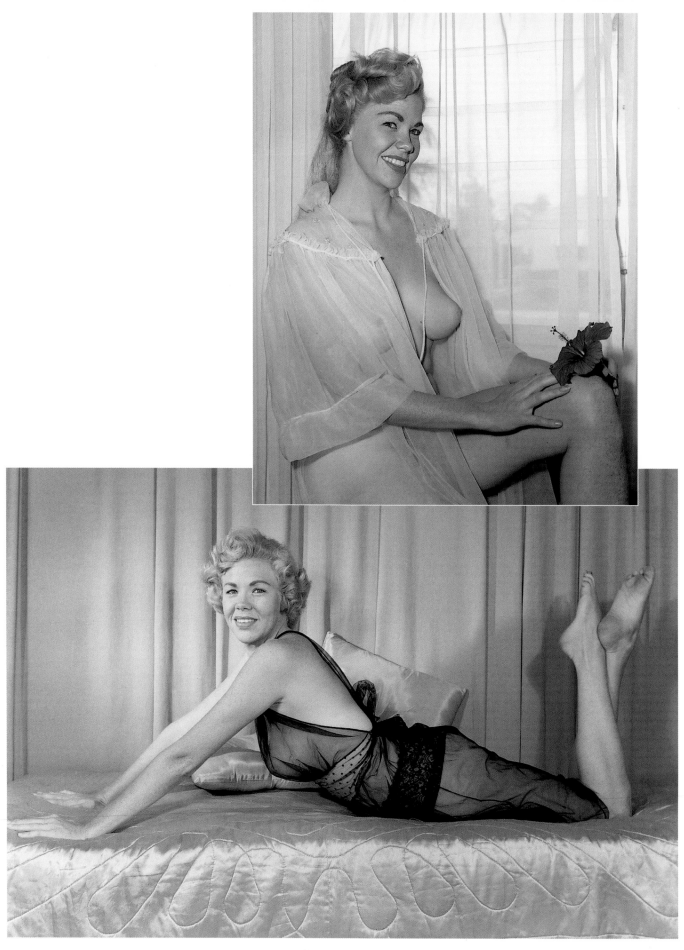

Ruth Shepard

44

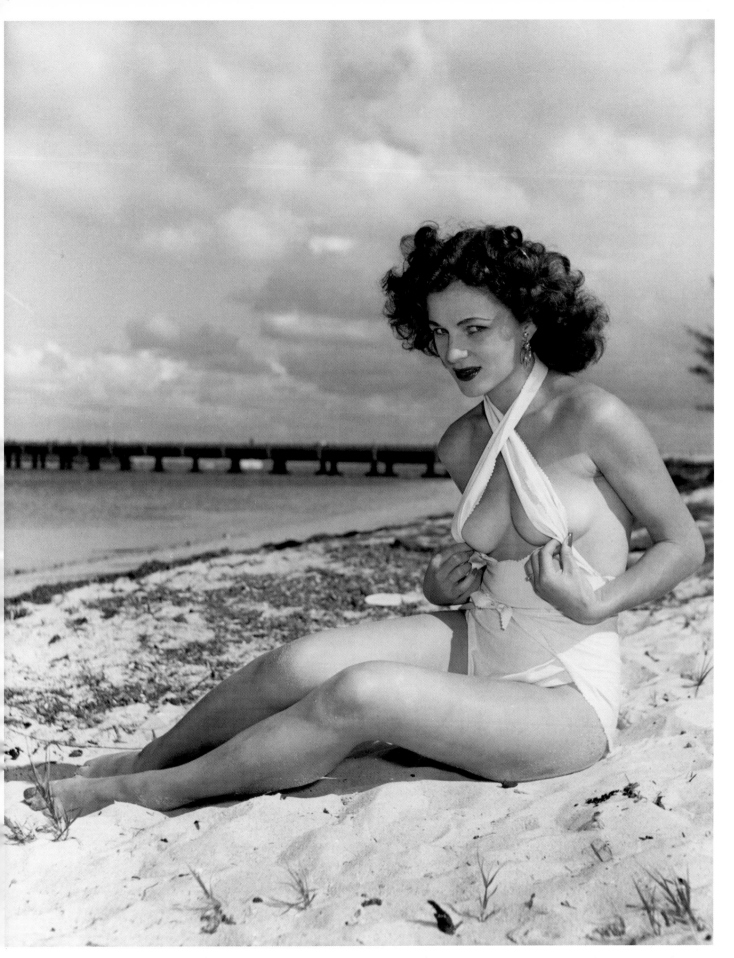

Yvonne Fredricks

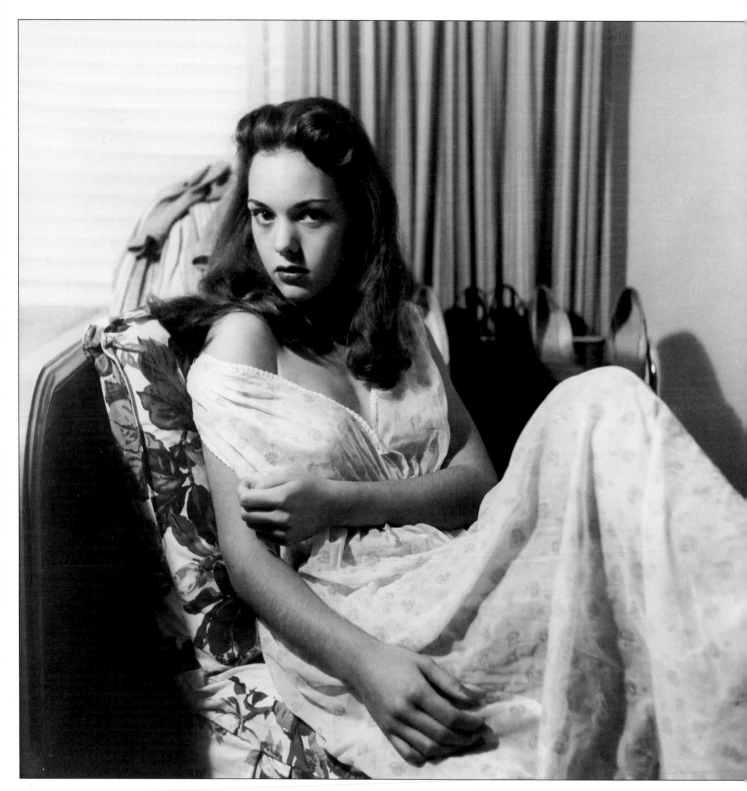

Mary Flynn

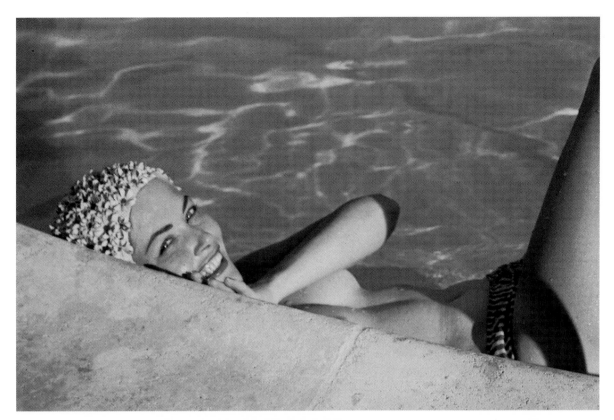

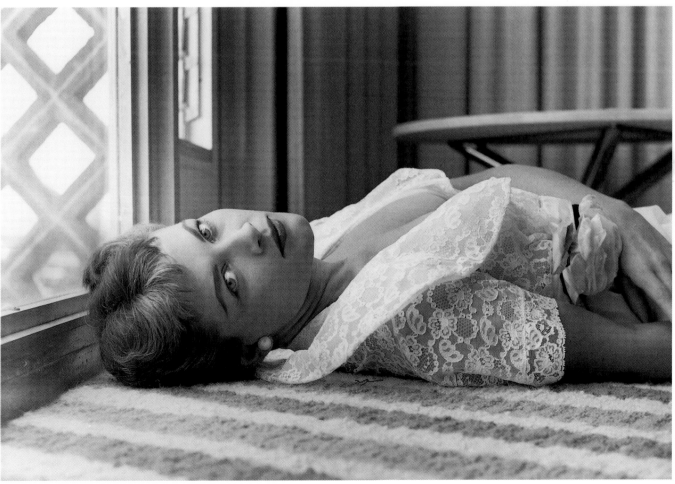

Jeanne Gallagher

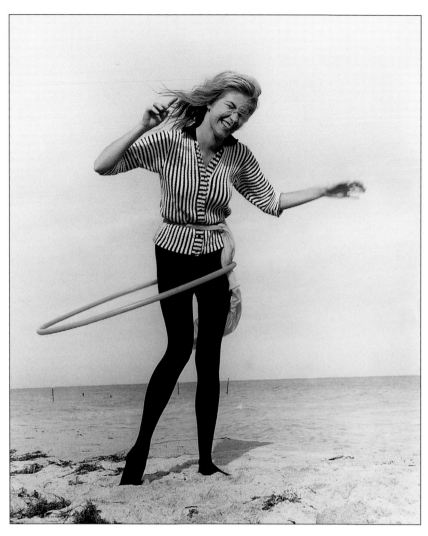

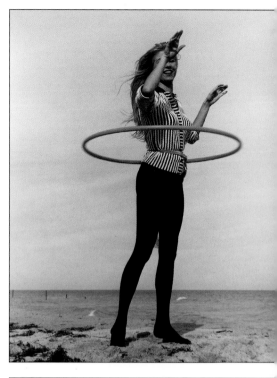

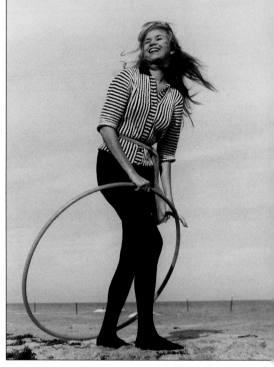

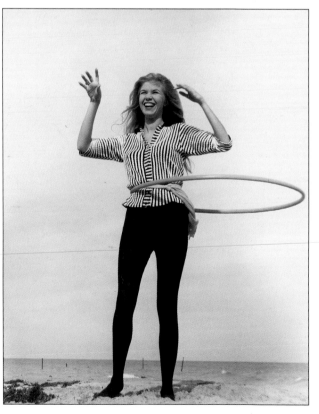

Bibi Grante

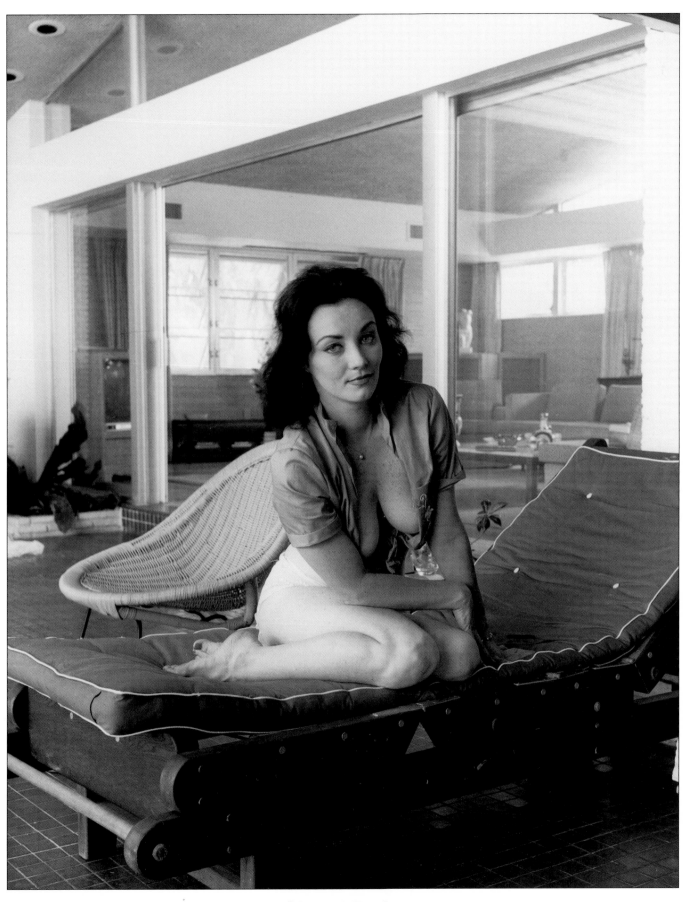

Sheryl Parks

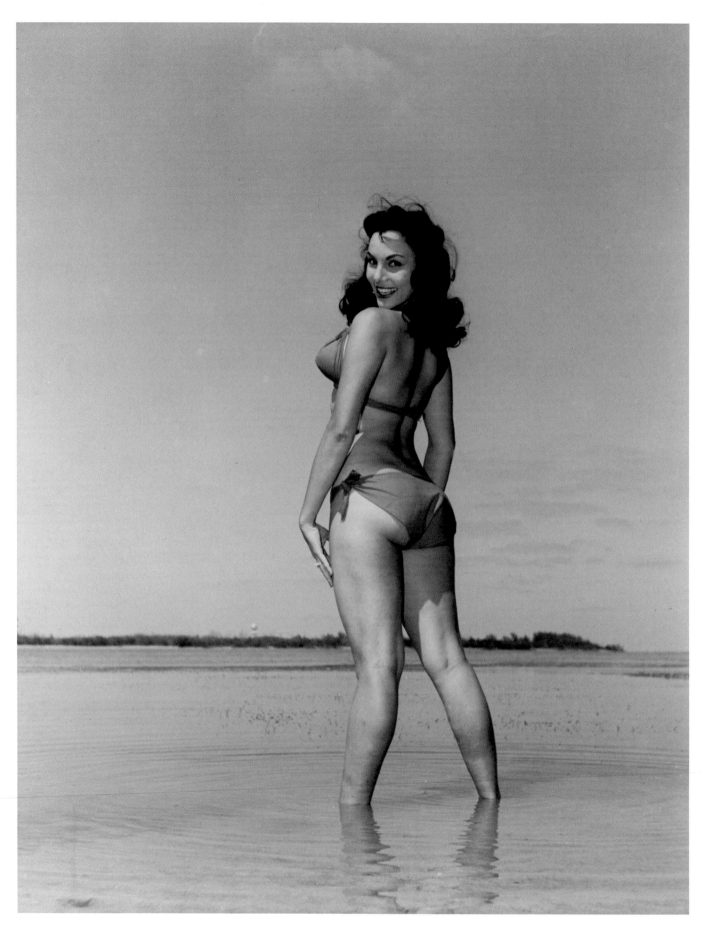

Chris Mara

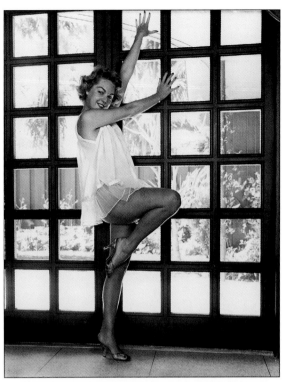

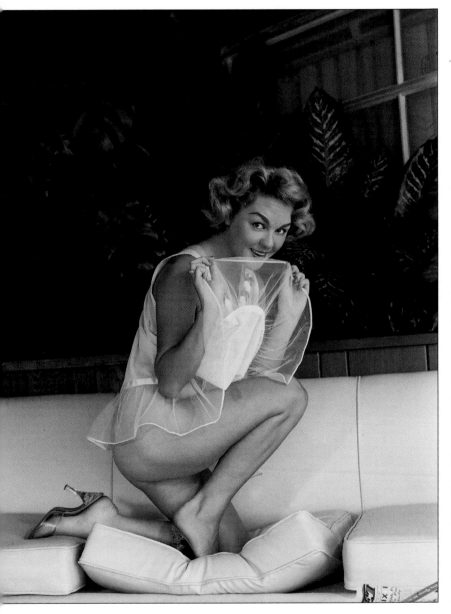

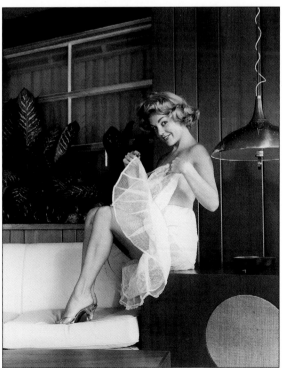

Scodie Hull

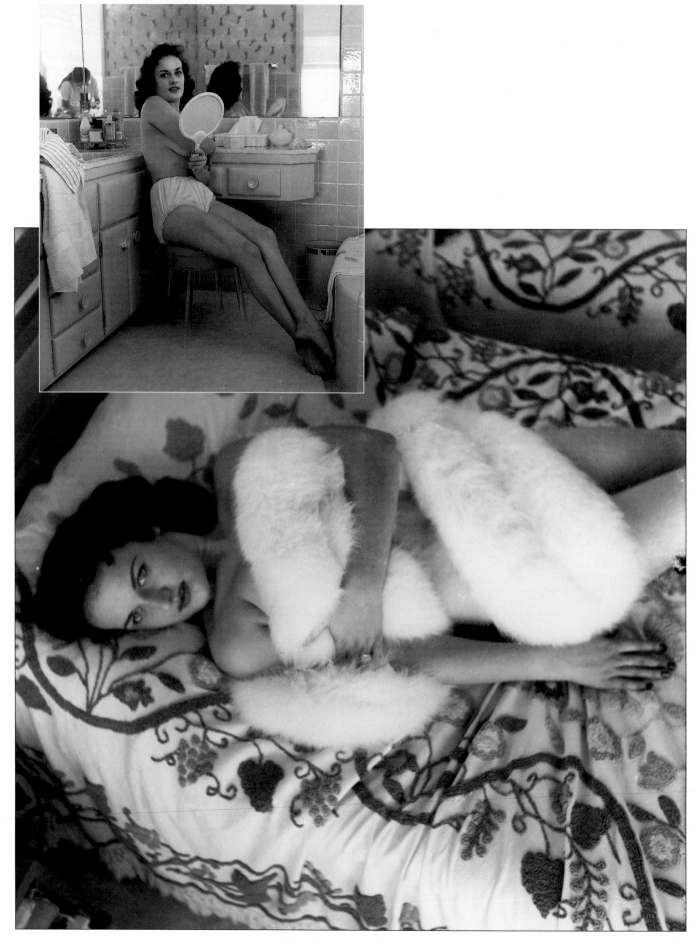

Marlayna Scott

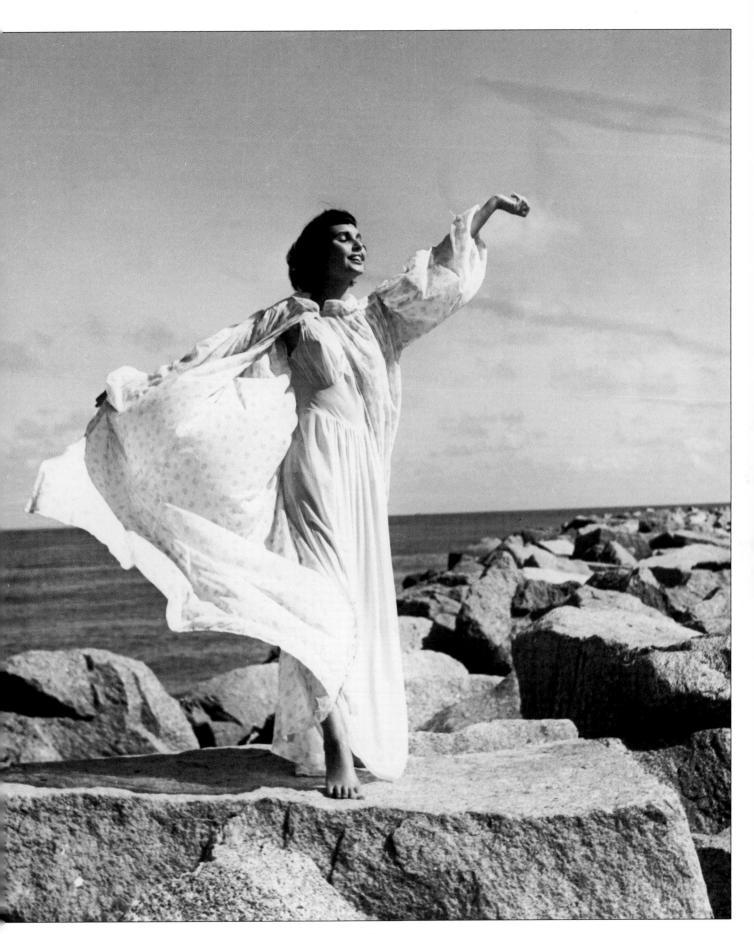

Terry Shaw

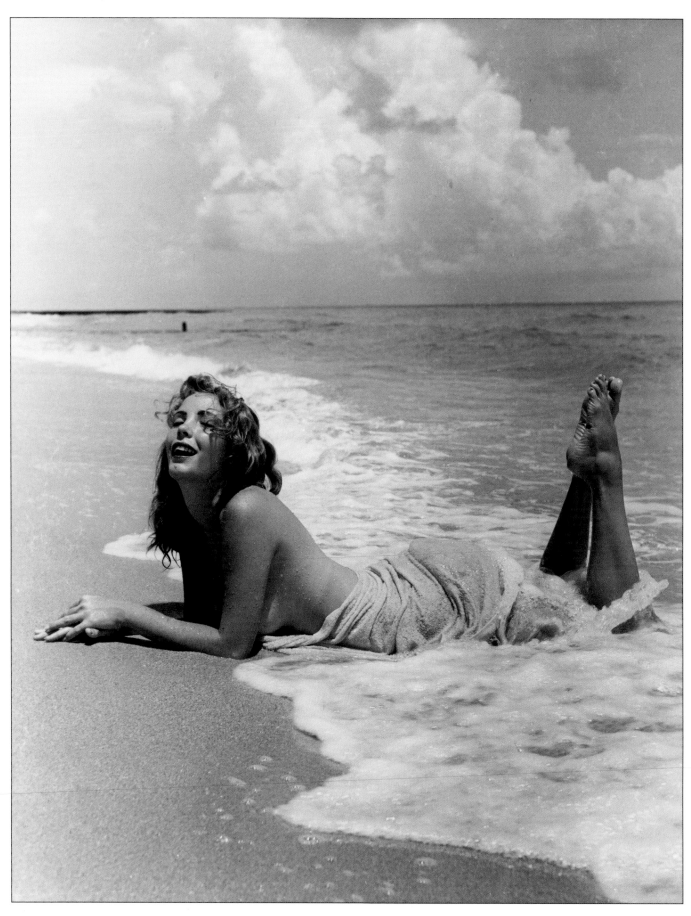

Phyllis Ursin

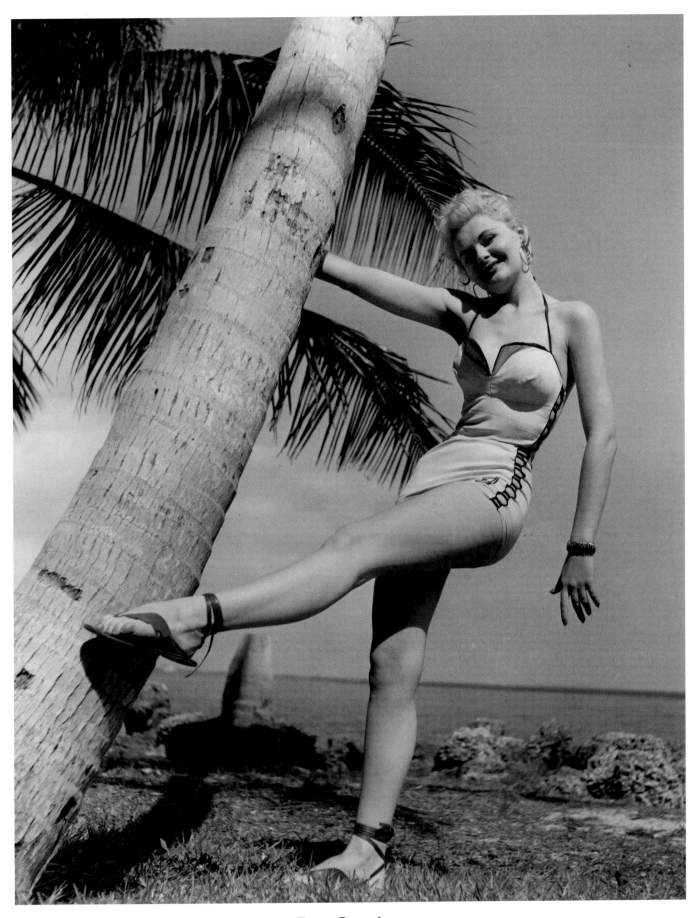

Pat Gardner

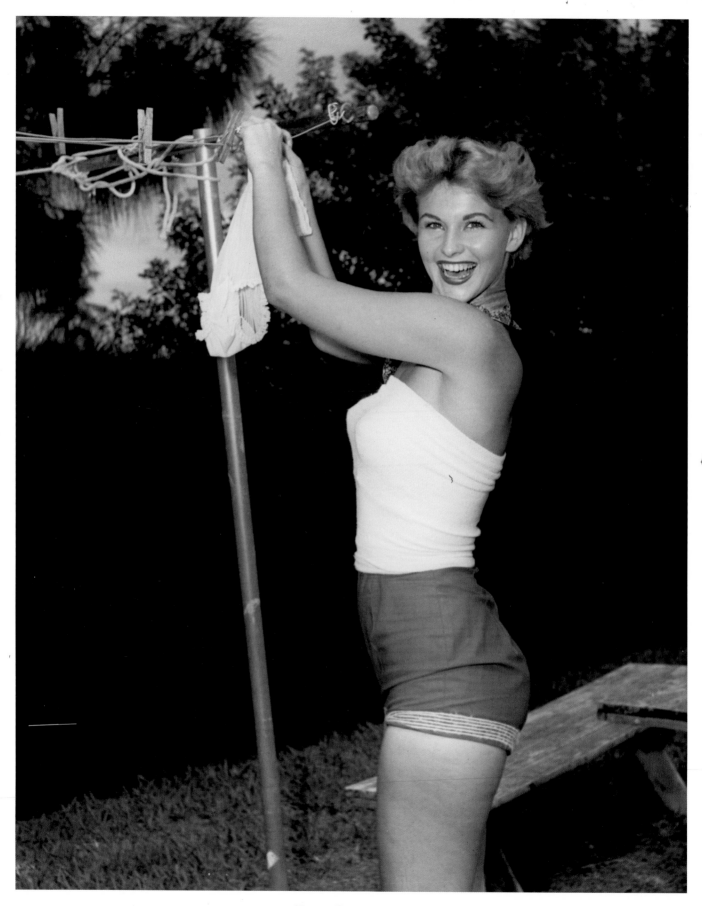

Pat Cooper

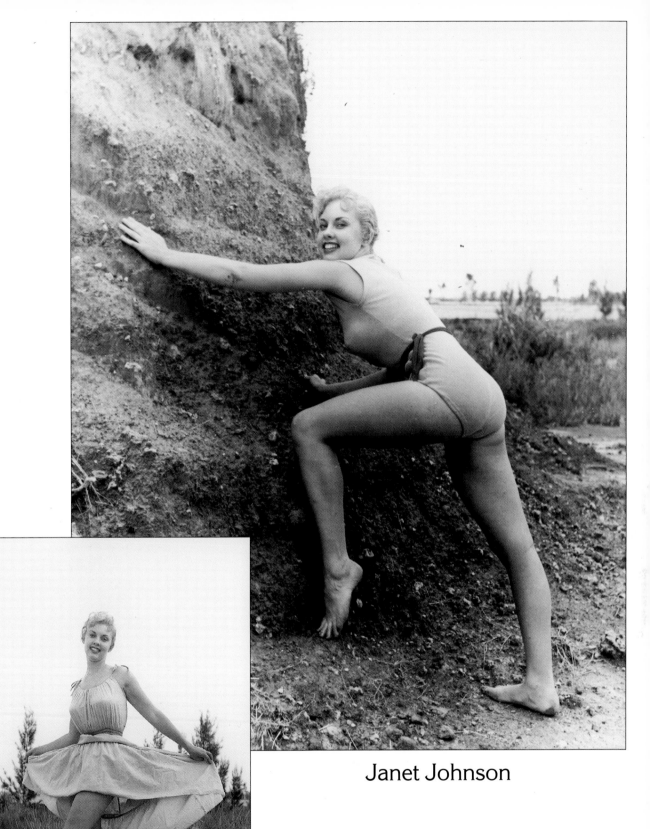

Janet Johnson

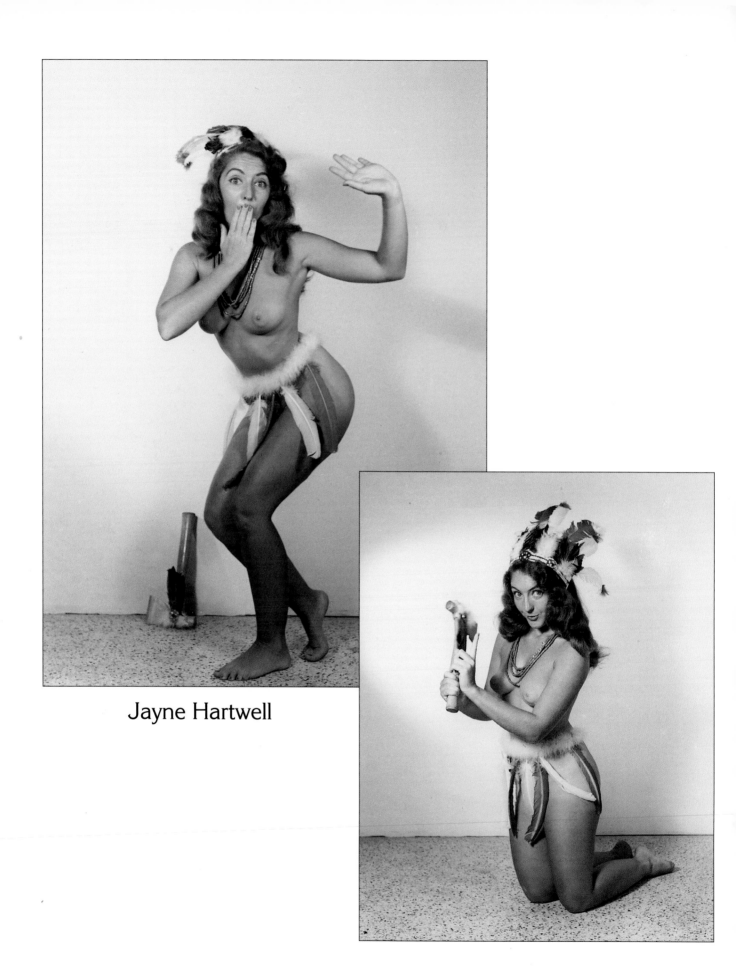

Jayne Hartwell

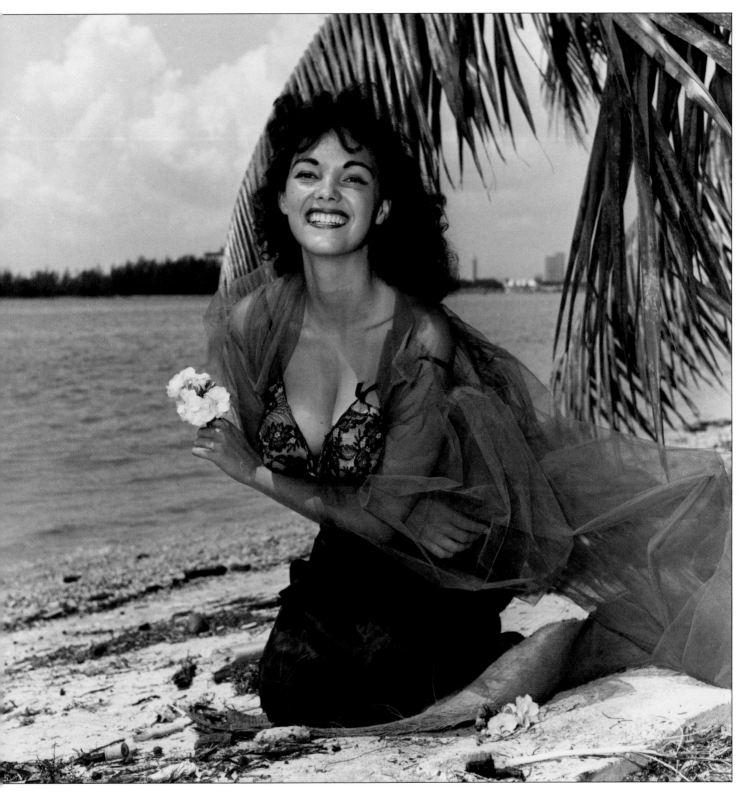

Jackie Walker

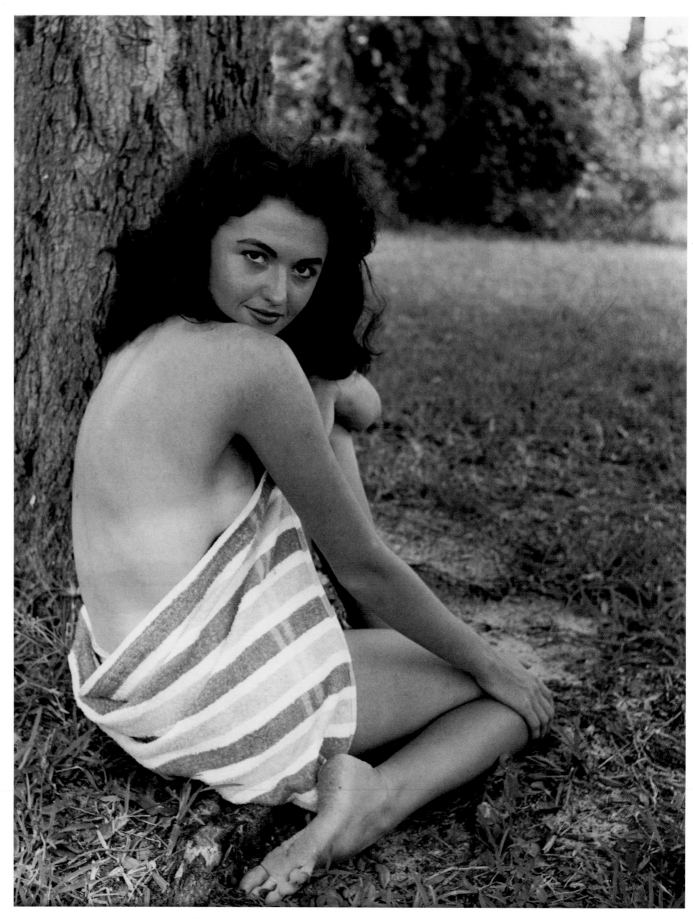

Nikki Wyatt

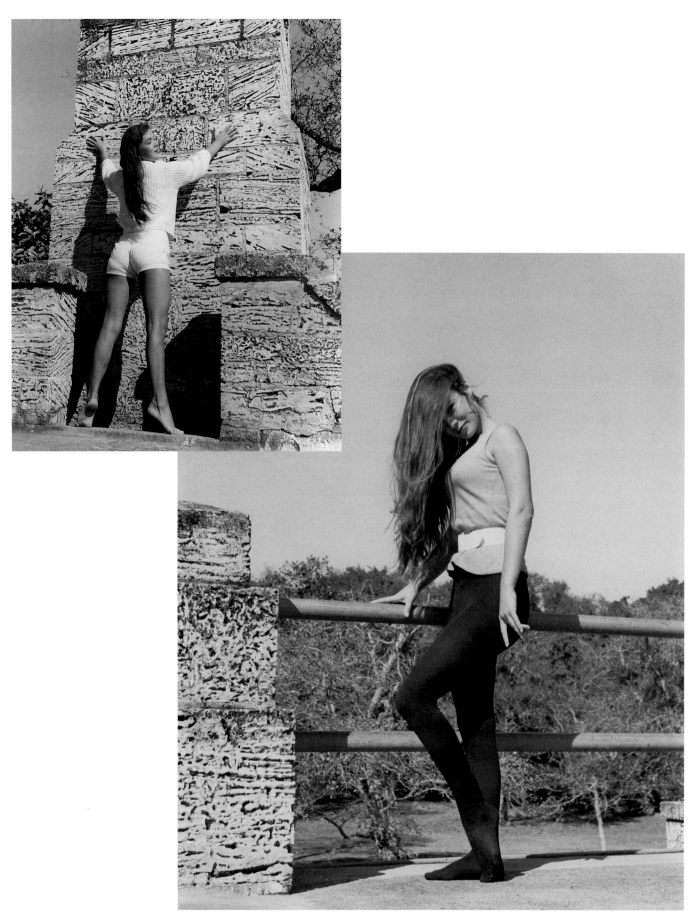

Dodie Mitchell

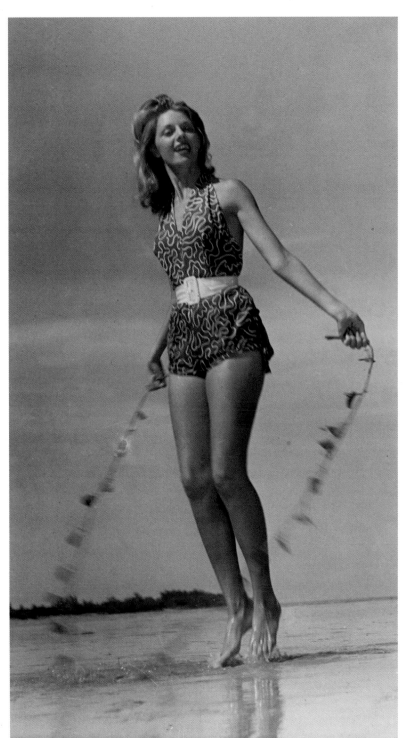

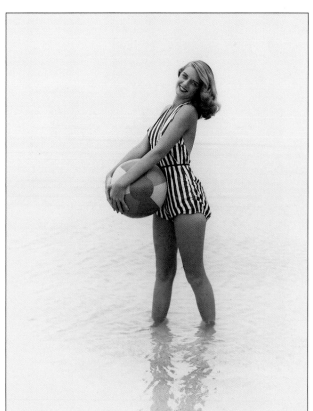

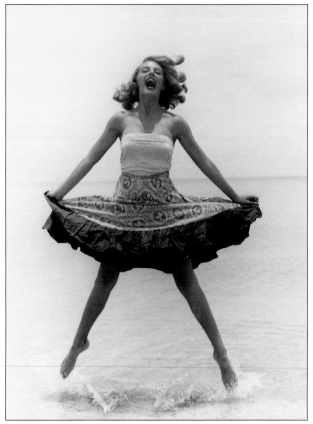

Florence Harrell

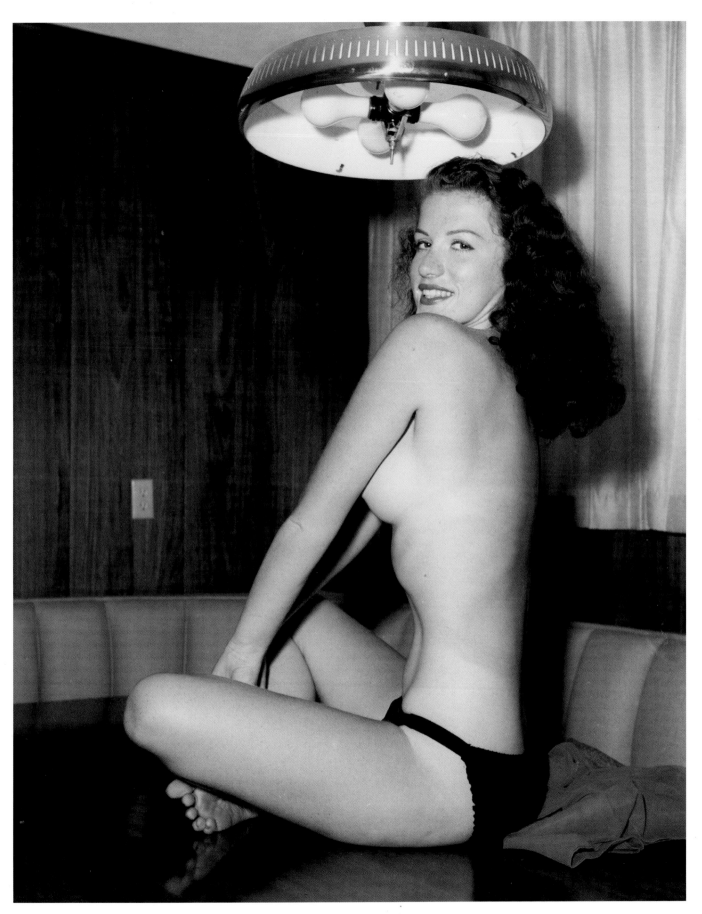

Ginger Martin

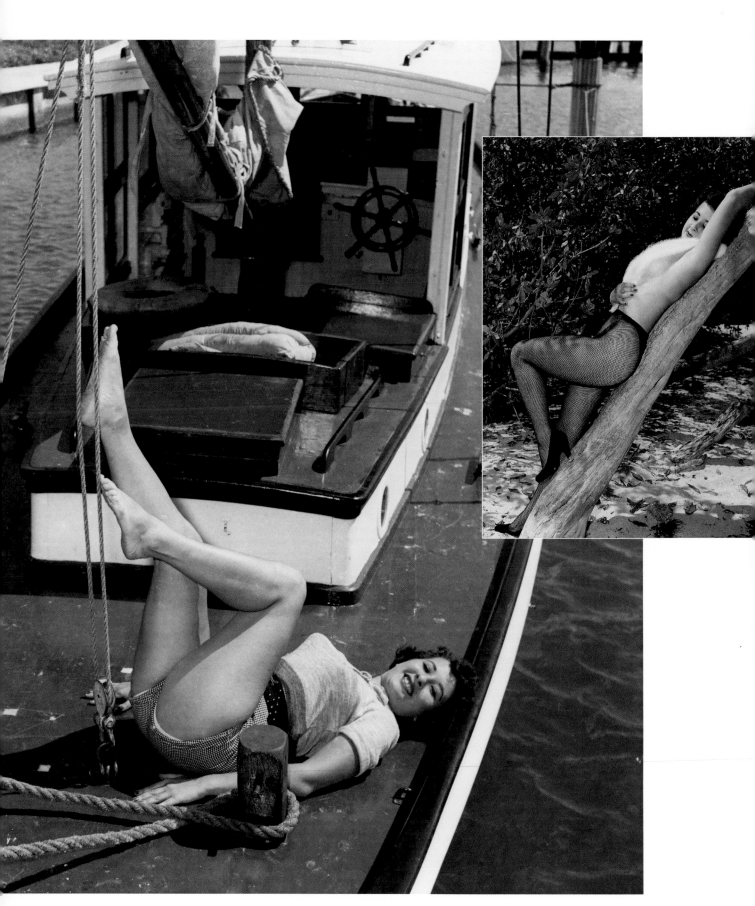

Rochelle Gallucci

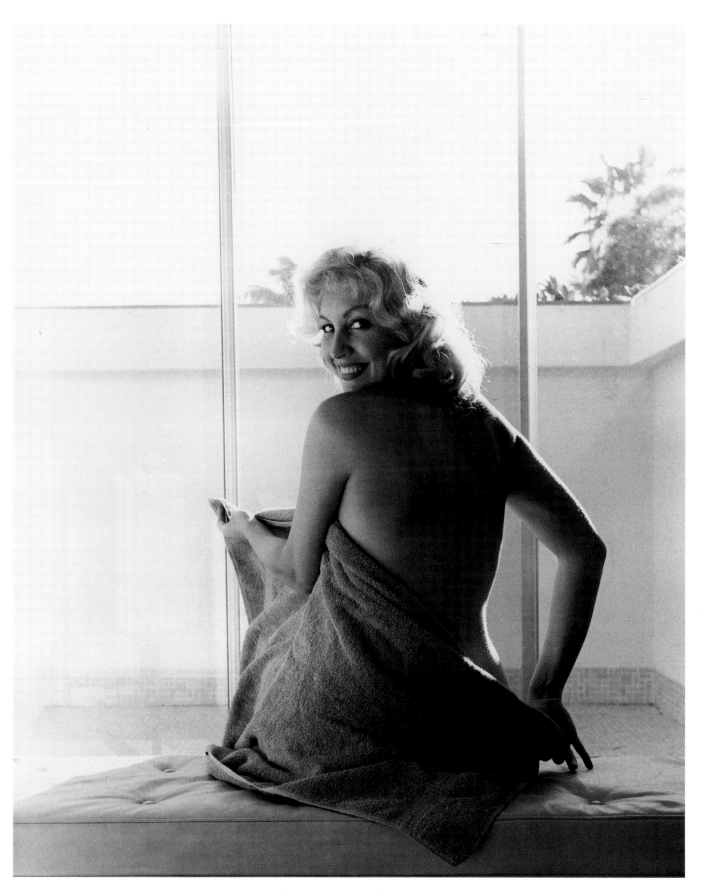

Peggy Jackson

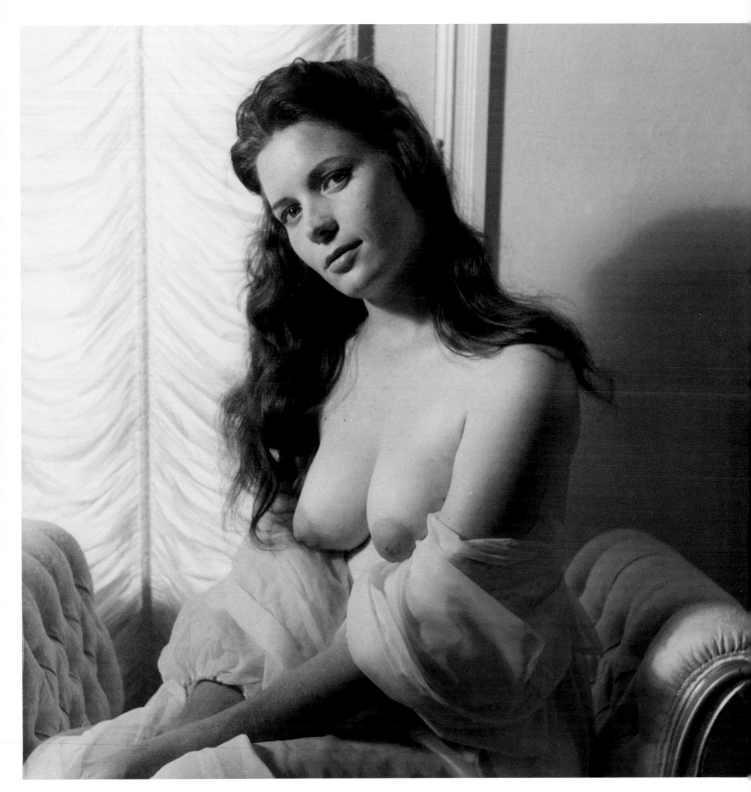

Val Ritchie

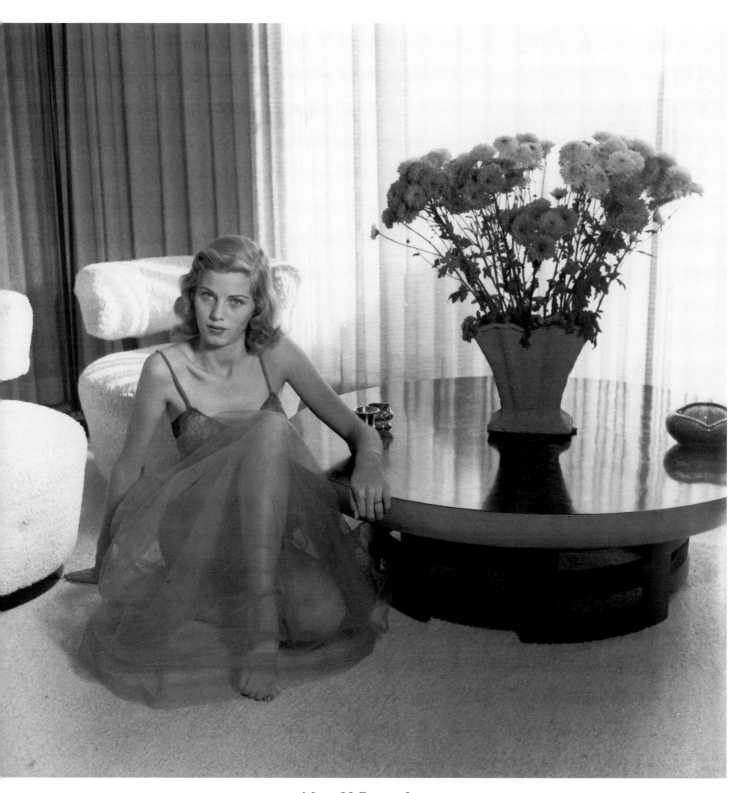

Alta Whipple

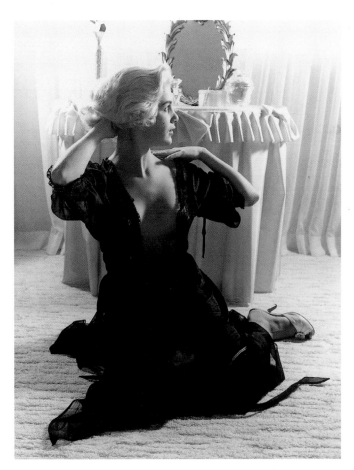

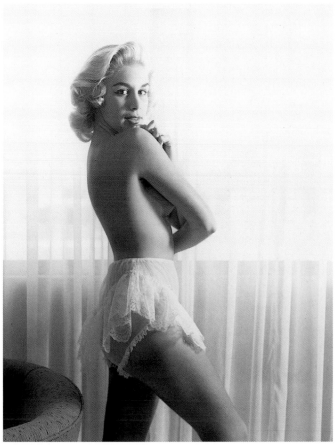

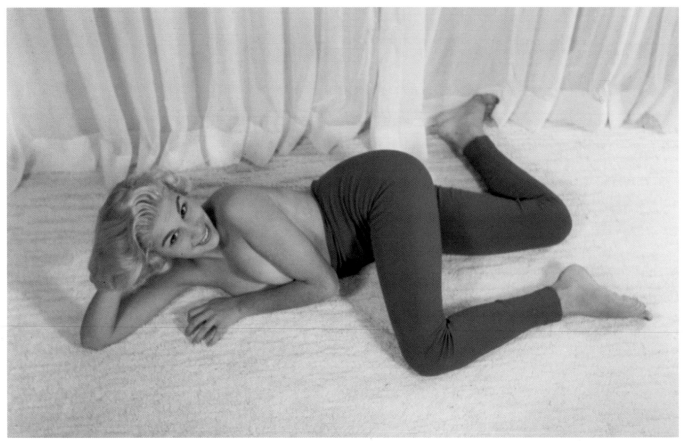

Inez Pinchot

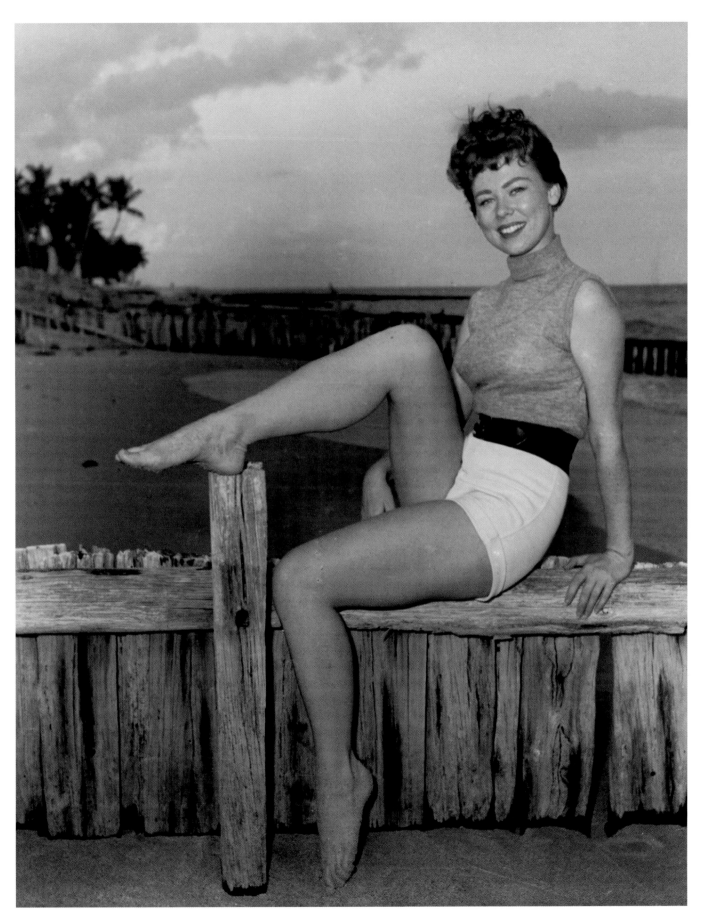

Sara Brockett

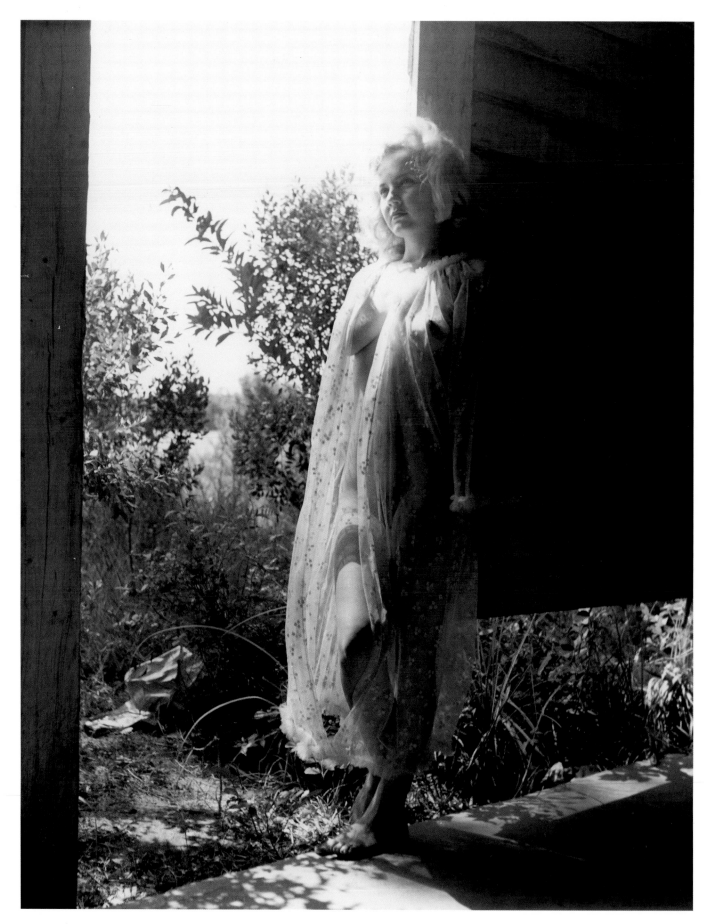

Sally Larimer

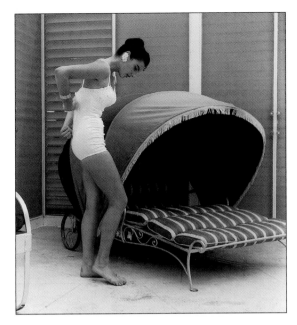

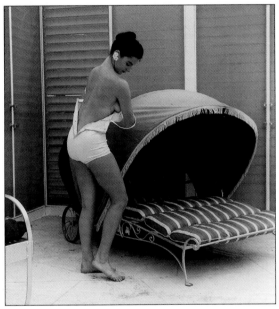

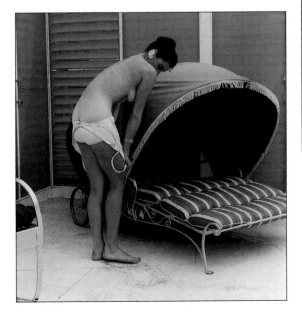

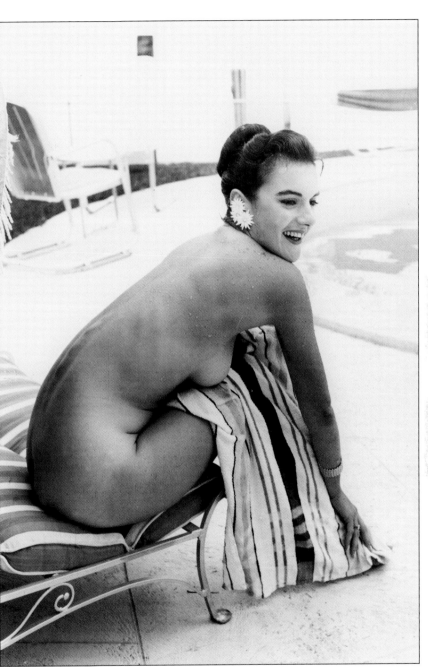

Rita Ramsey

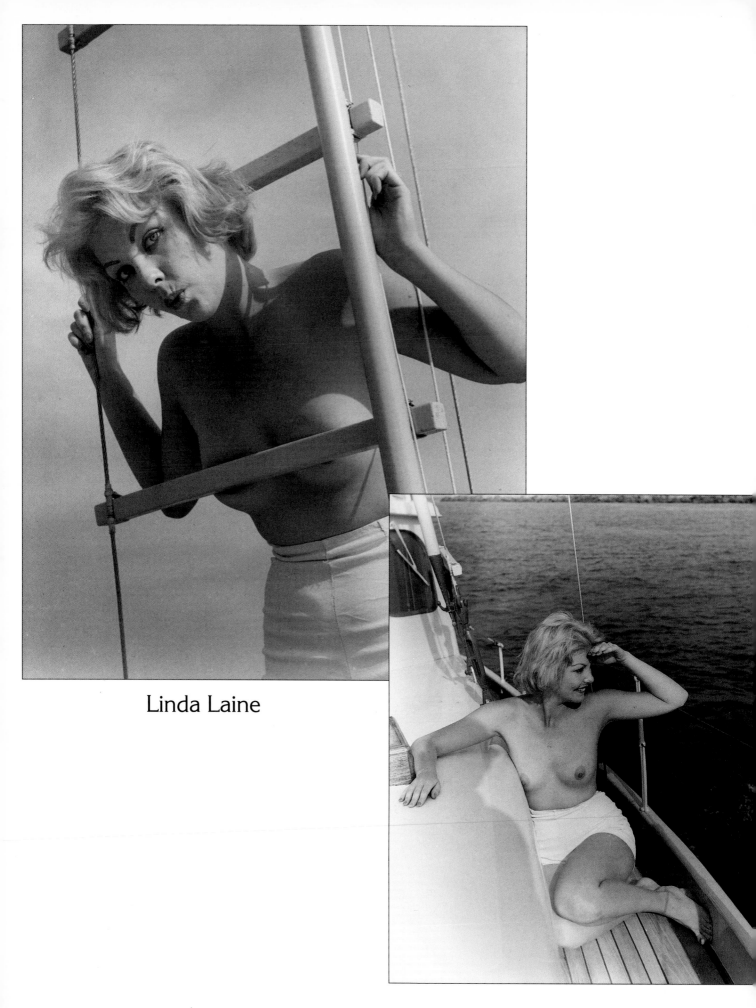

Linda Laine

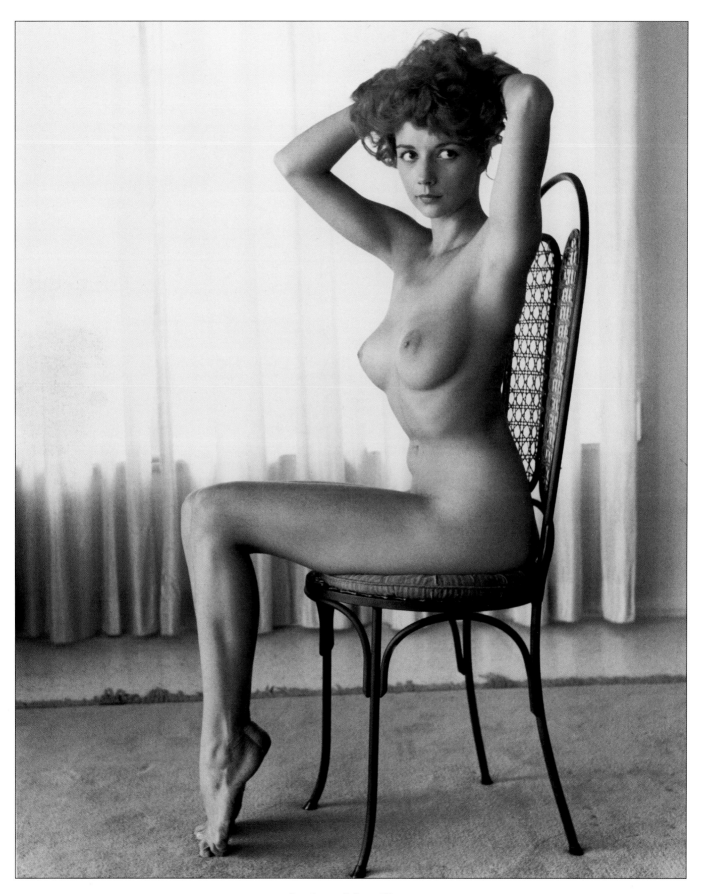

Anita Mc Crea

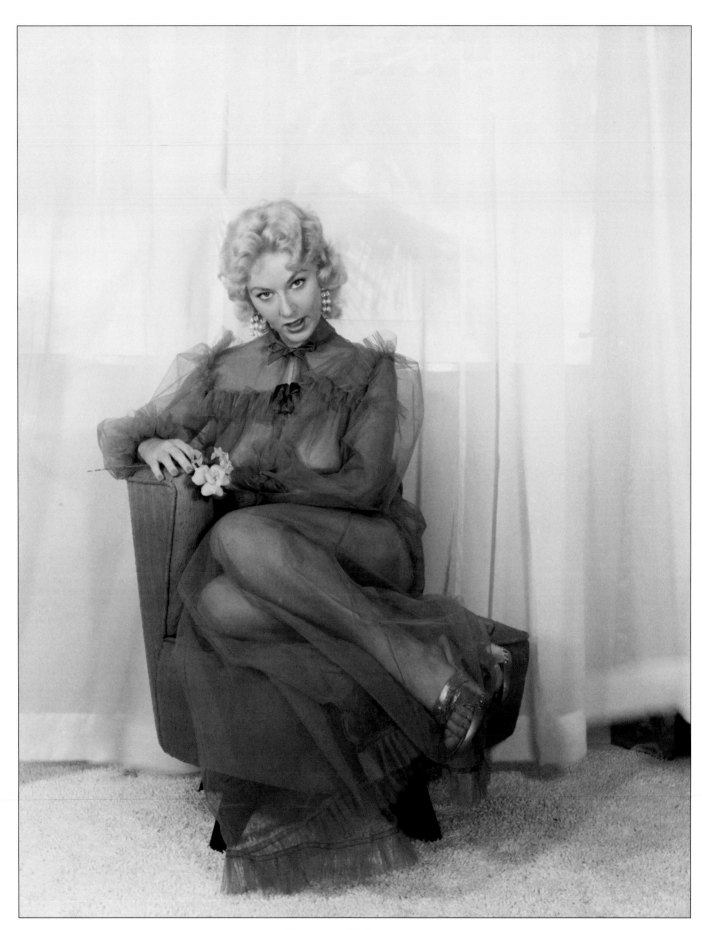

Diane Wagner

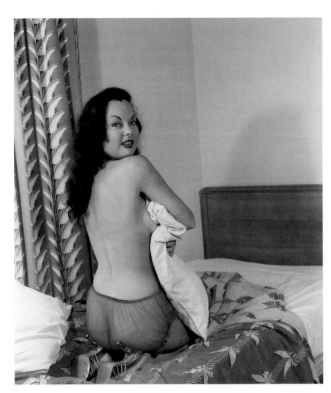
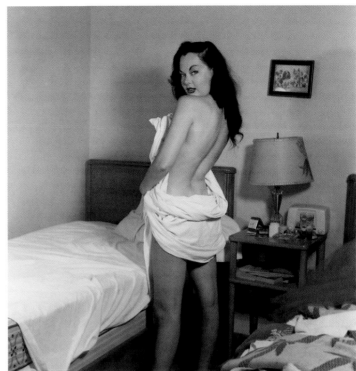
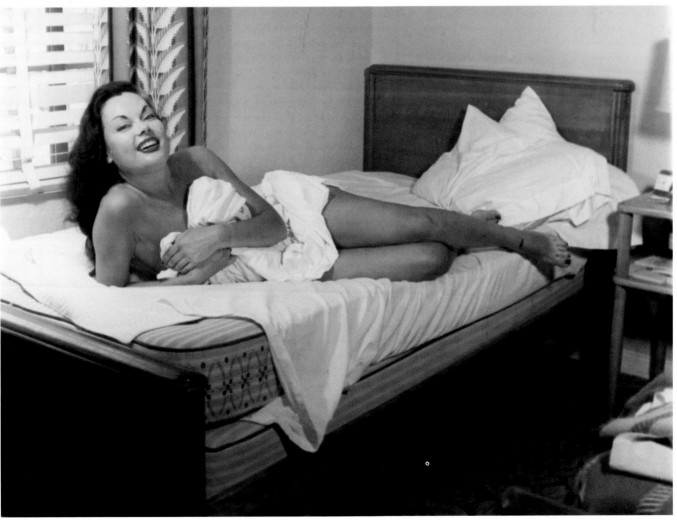

Mara Lindsey

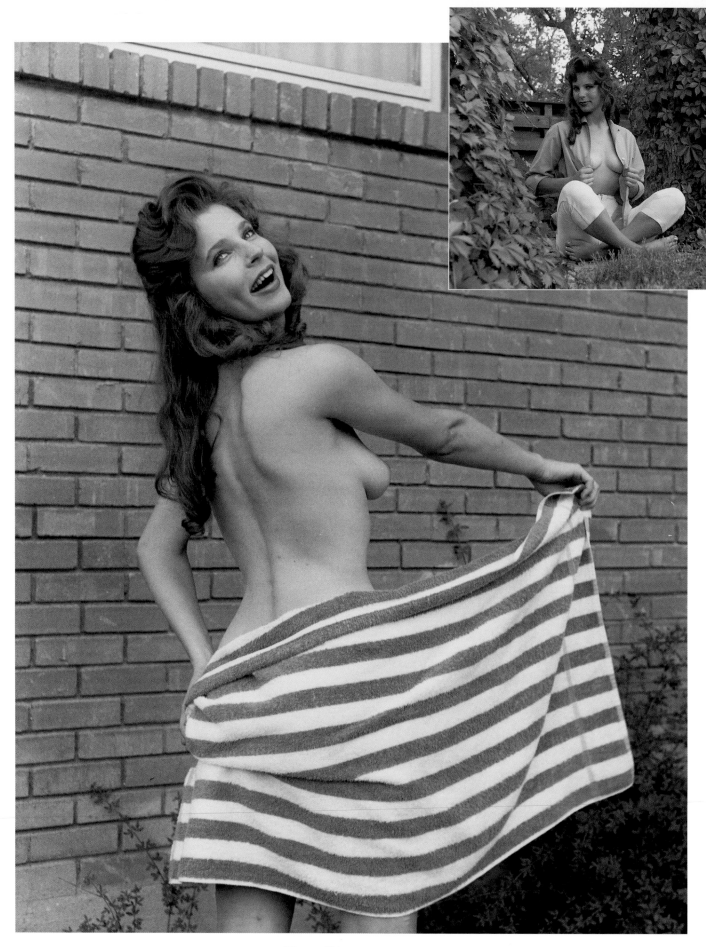

Pat Simmons

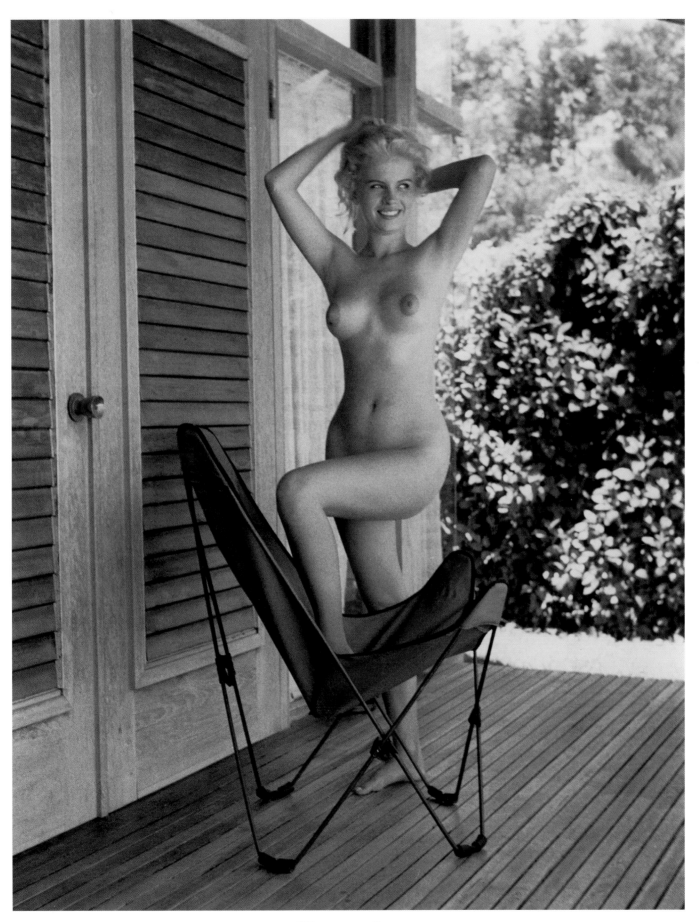

Sharon Lee

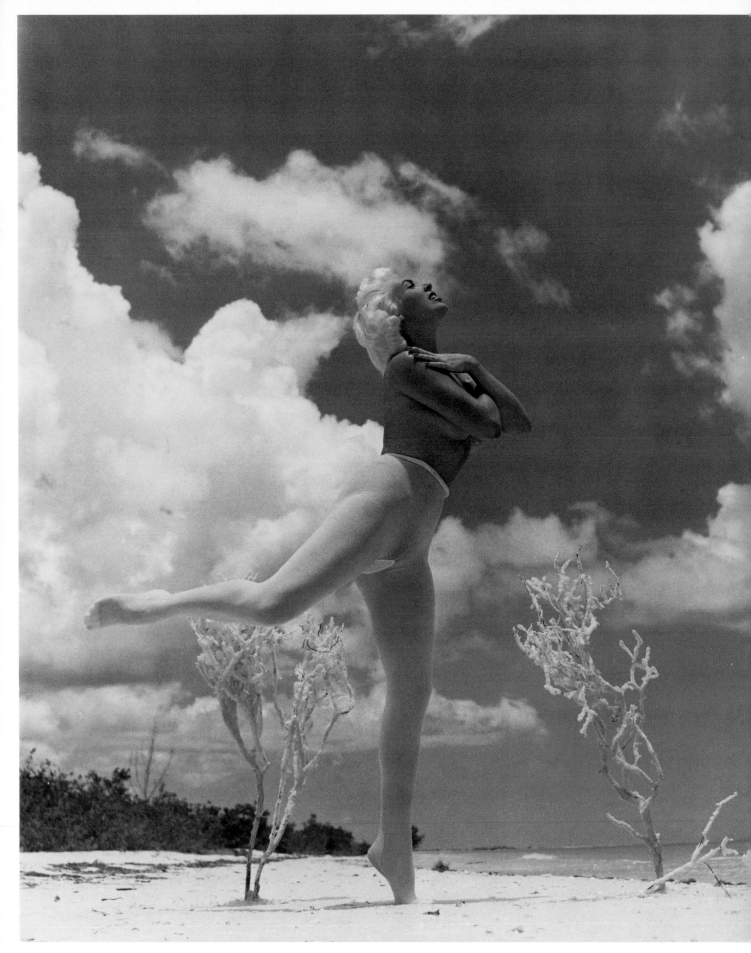

Lori Shea

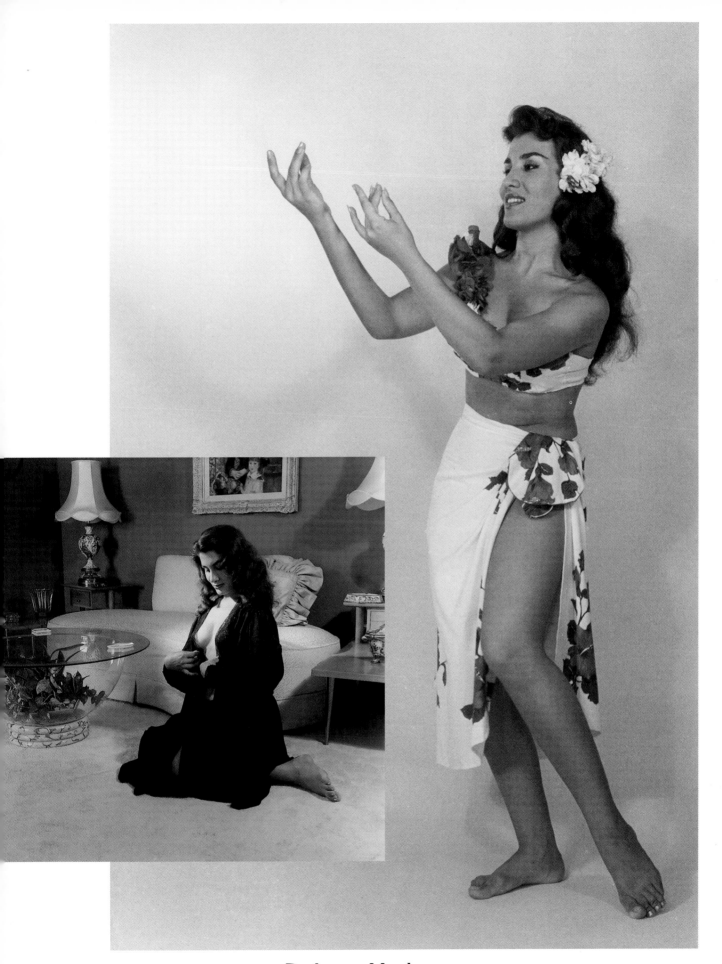

Dolores Hodges

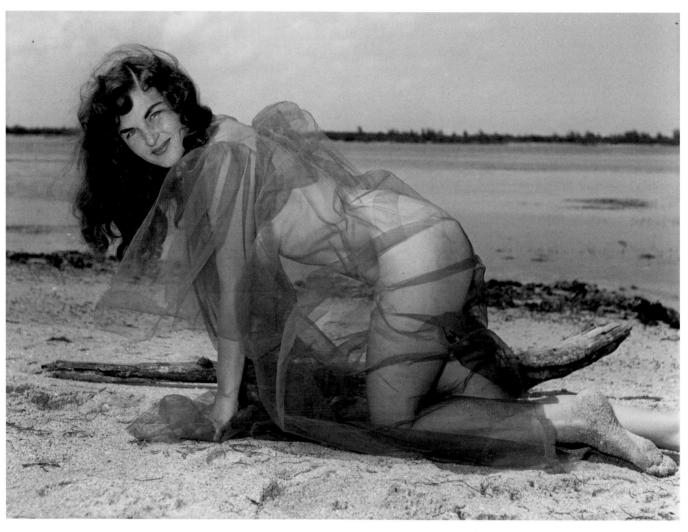

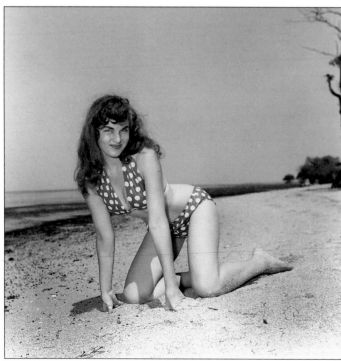

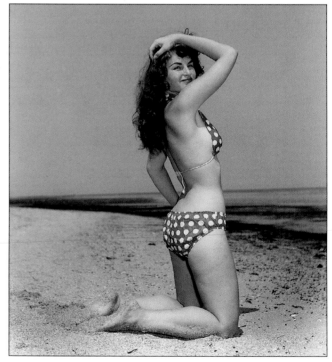

Sue James

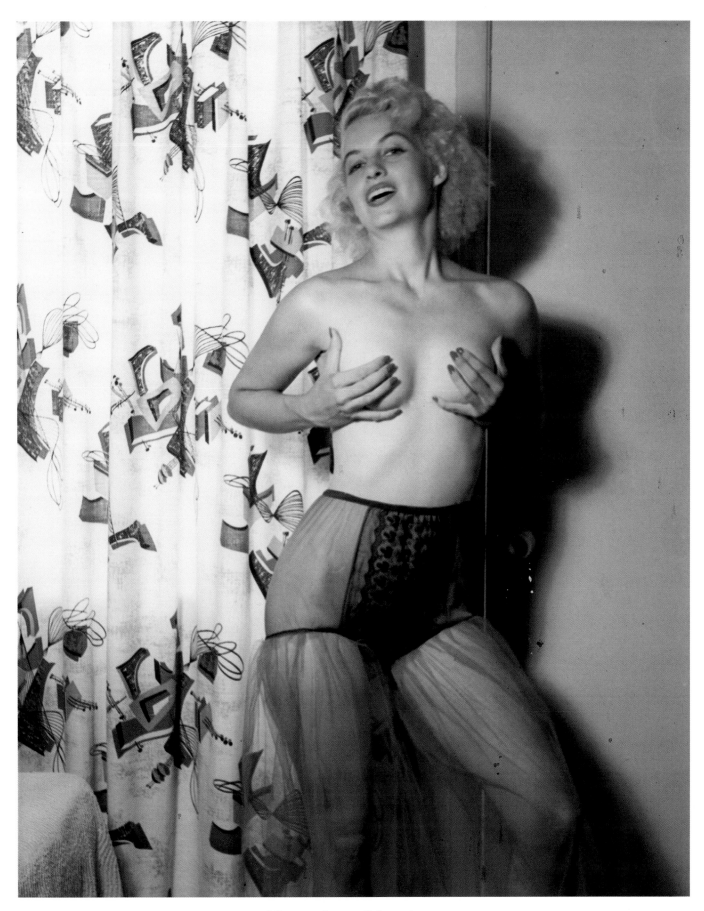

Mary Ann Harrison

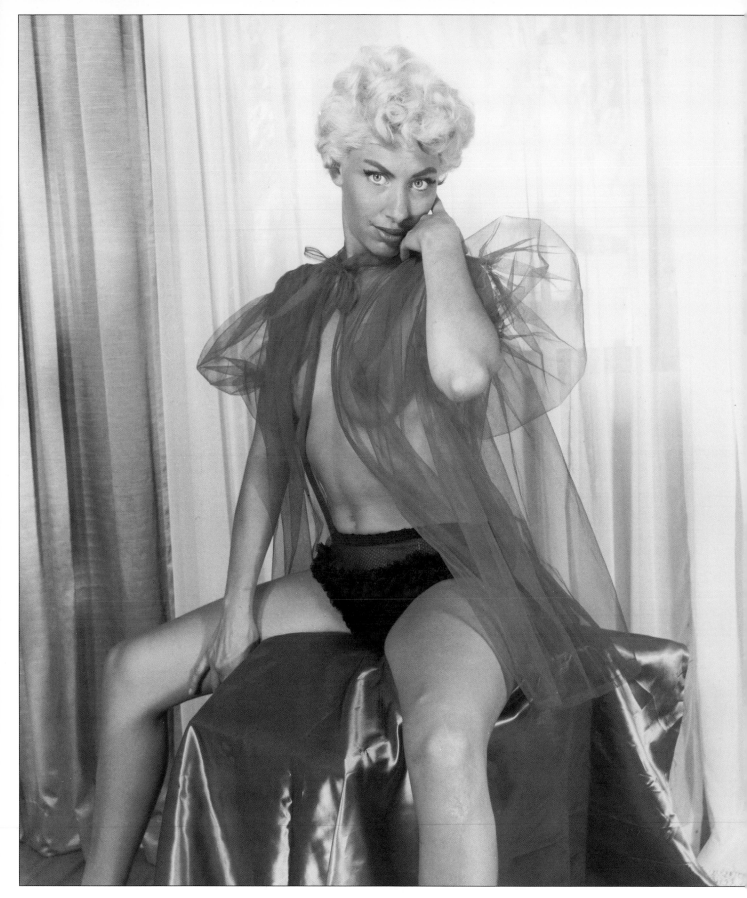

Sharon Knight

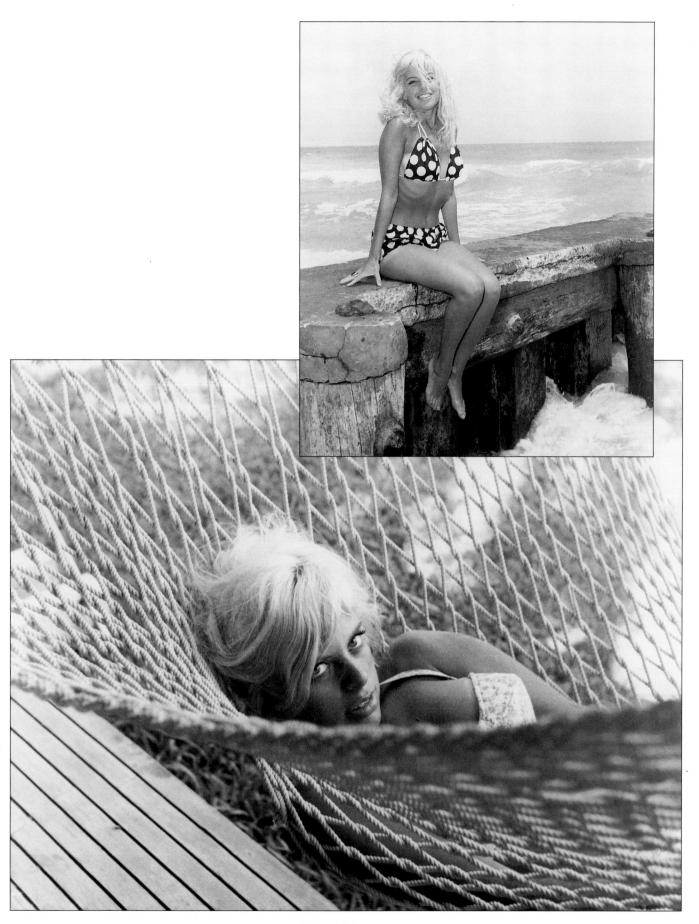

Teri Hope

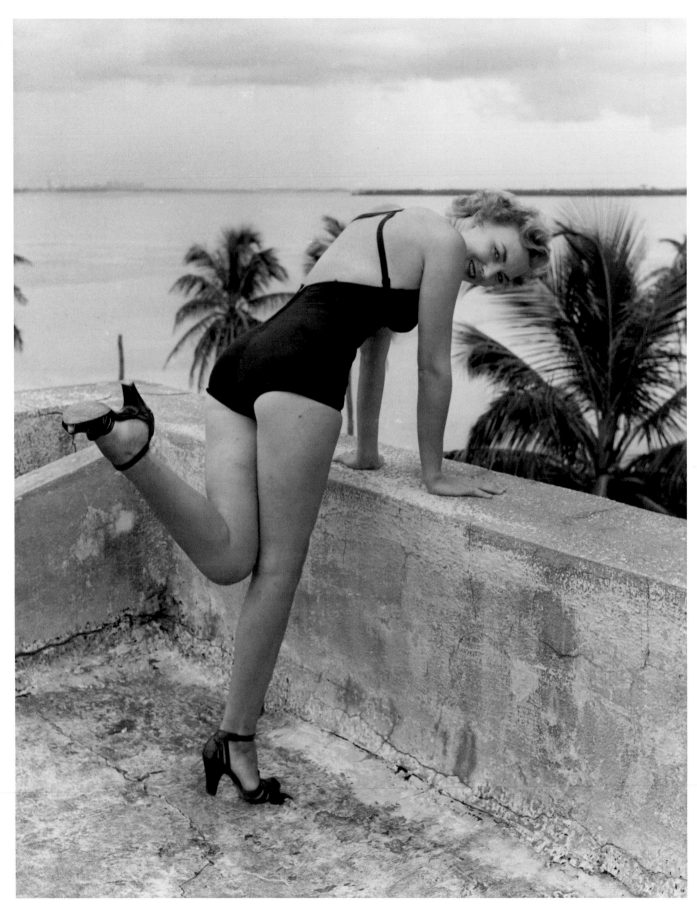

Marcella Patrick

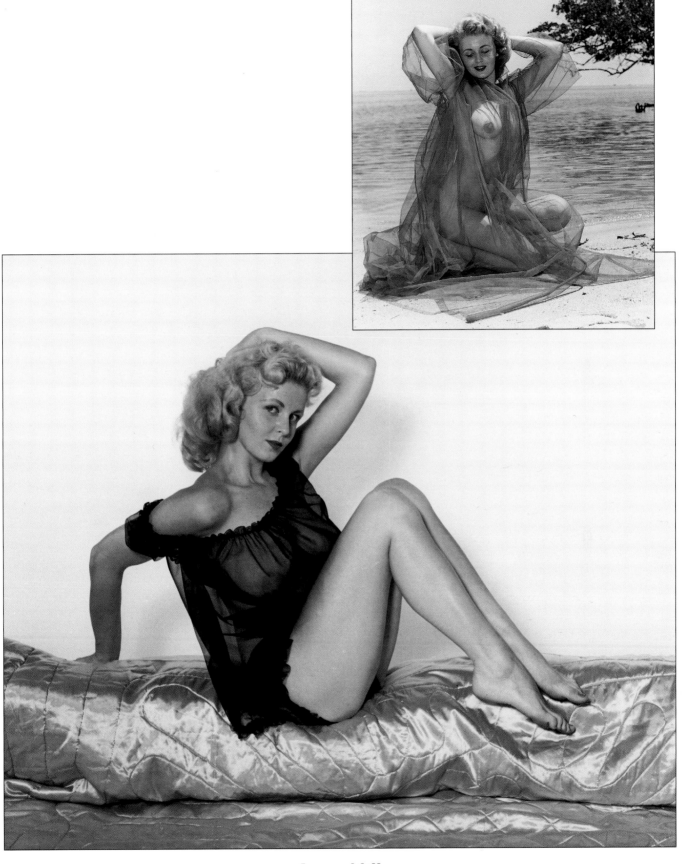

Jane Millar

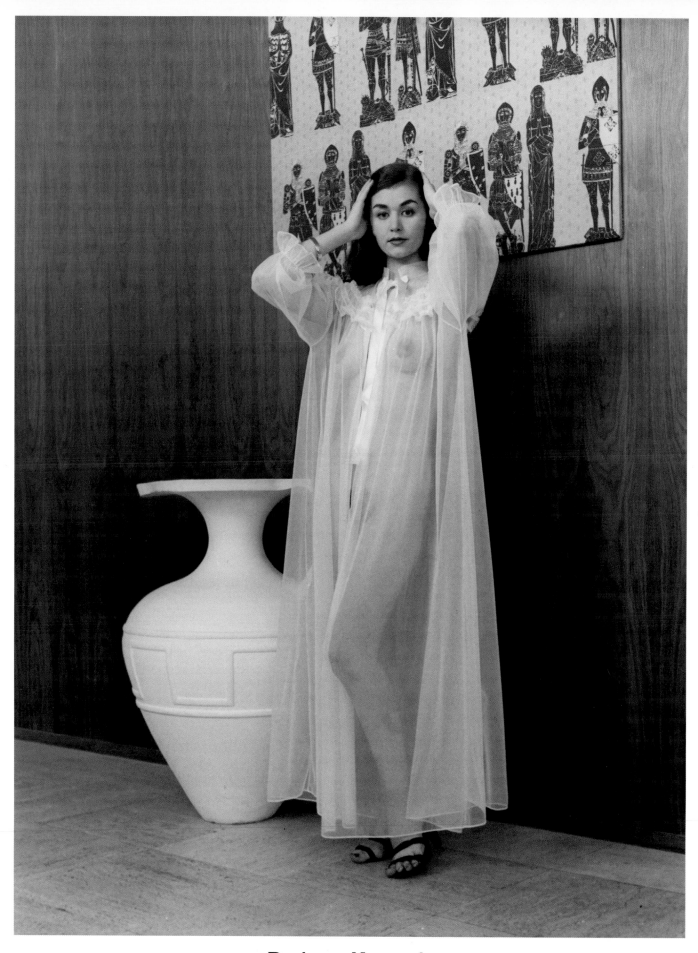

Barbara Karwath

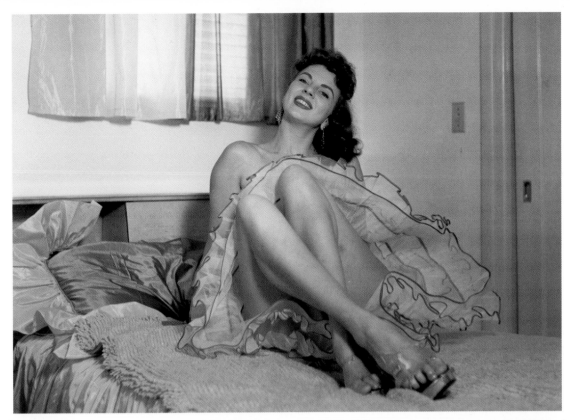

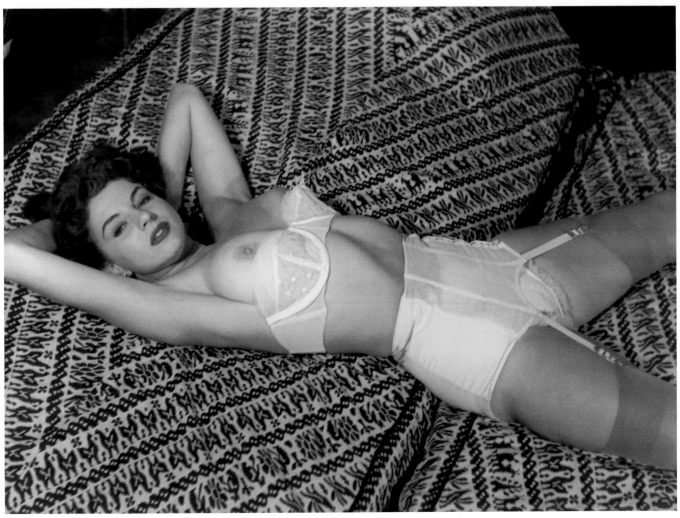

Jackie Miller

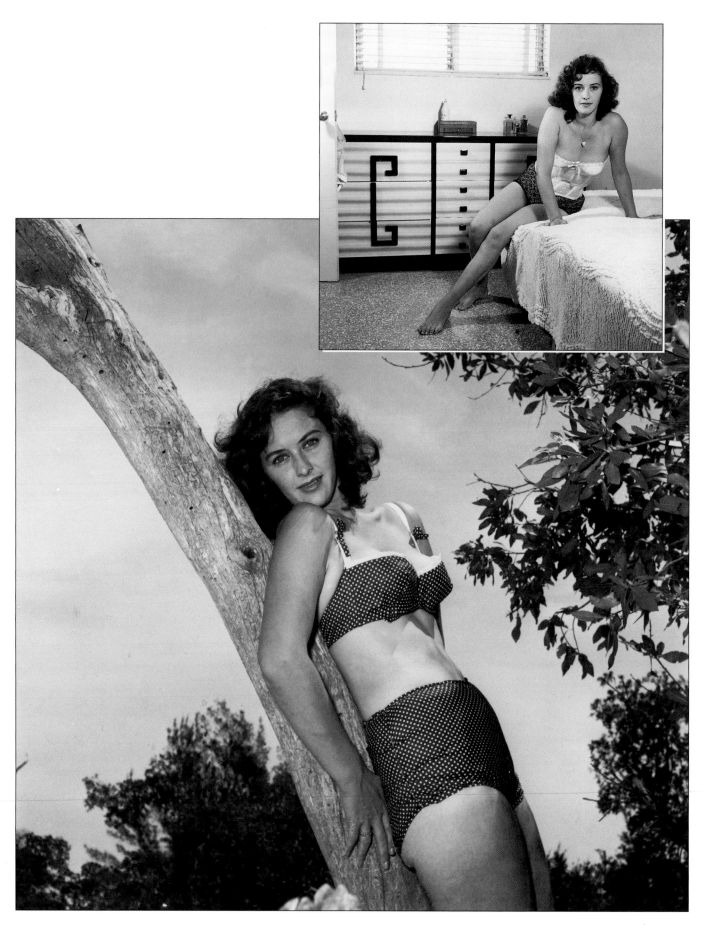

Virginia Remo

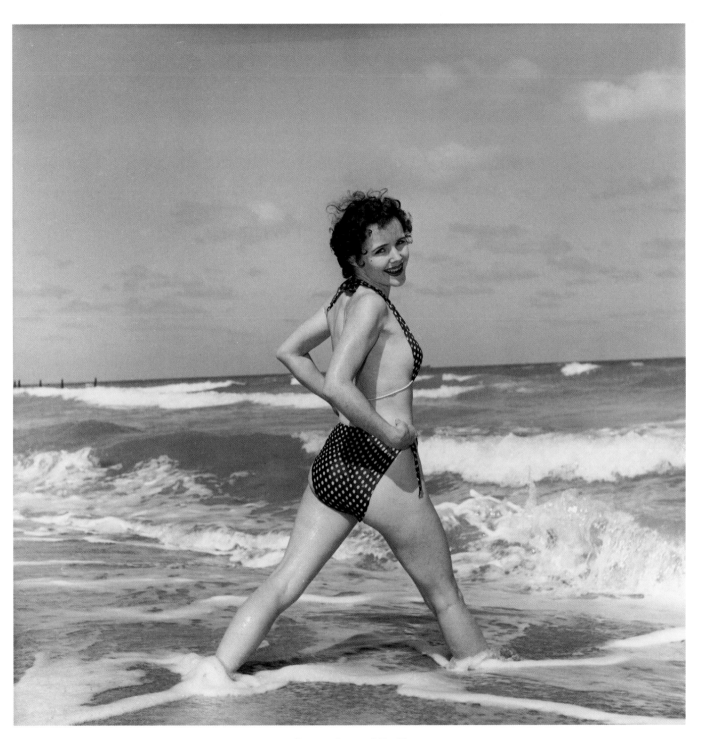

Carolyn Kelly

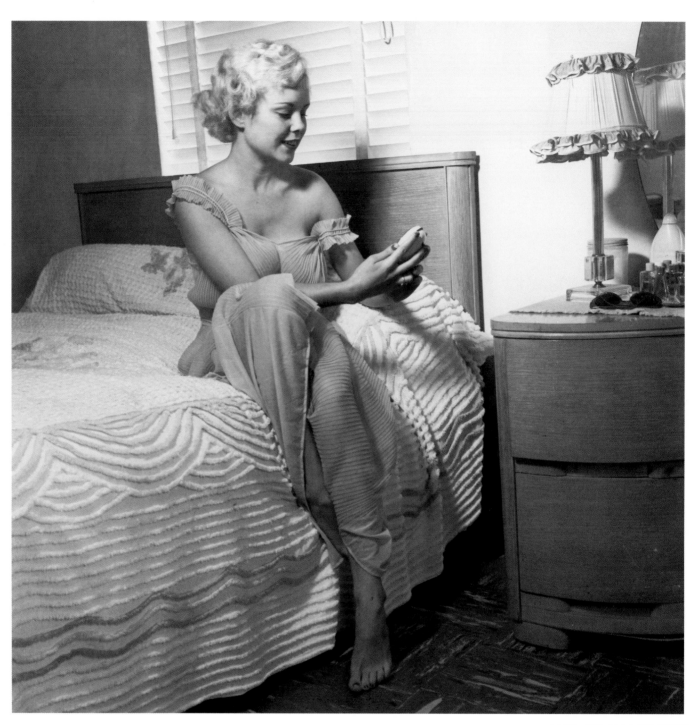

Patti Simmons

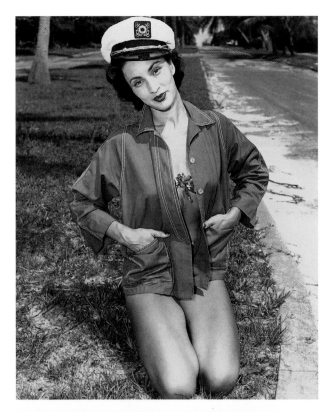

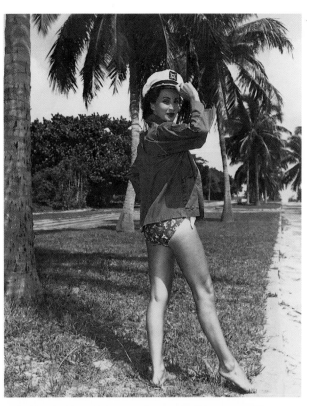

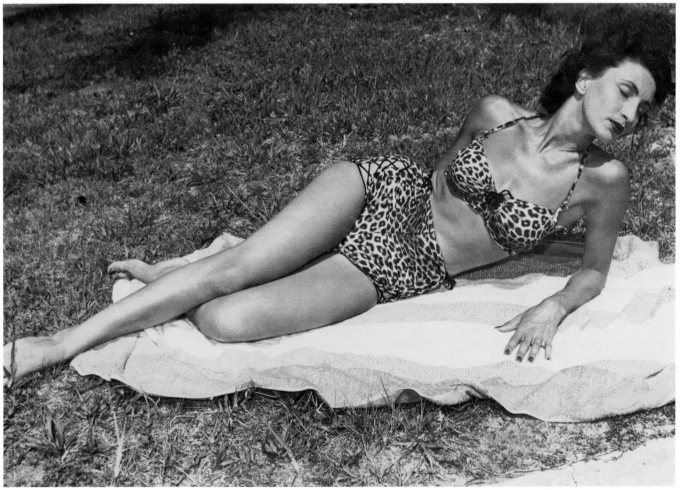

Marcella Hansen

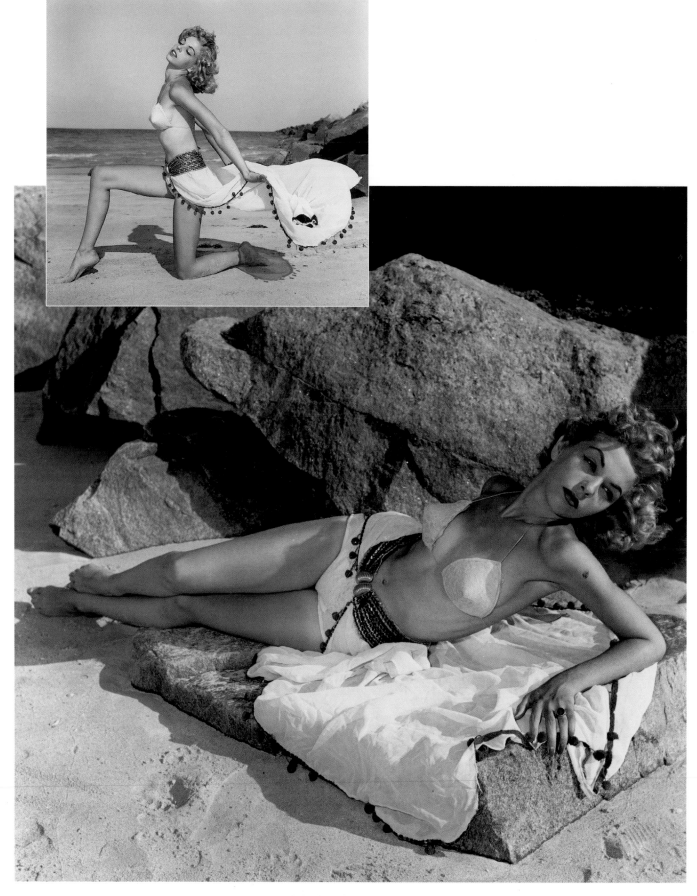

Melody West

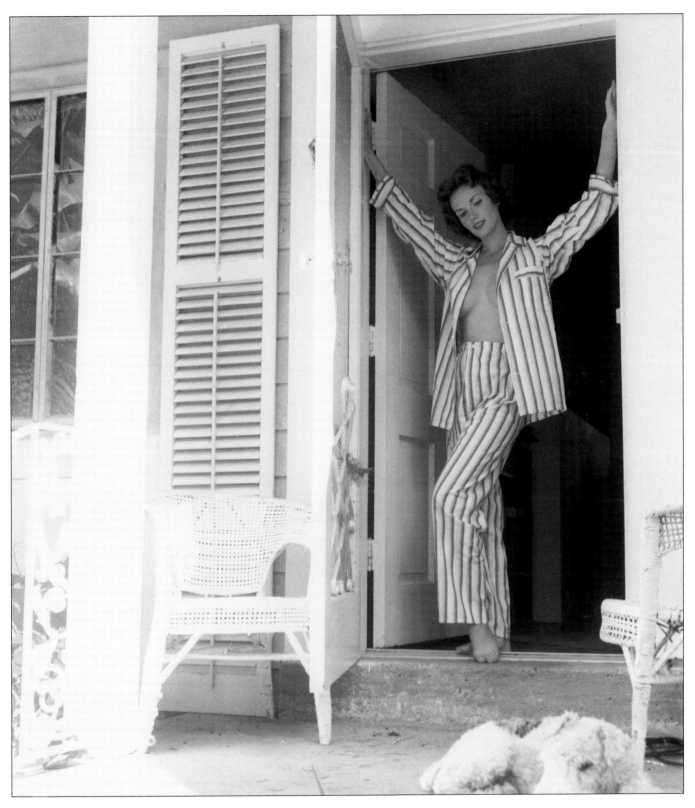

Lacey Kelly

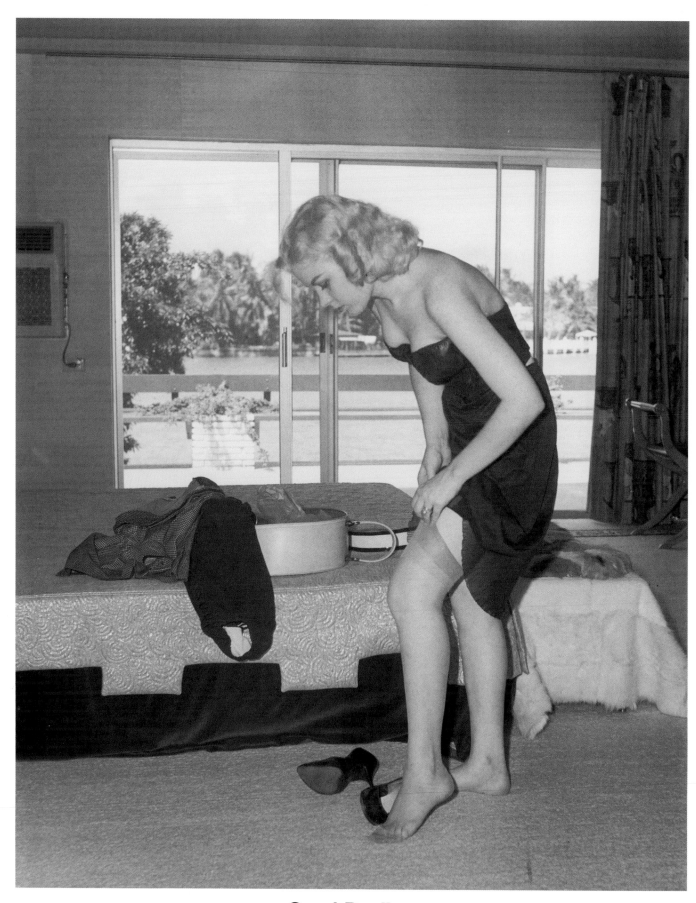

Carol Paullus

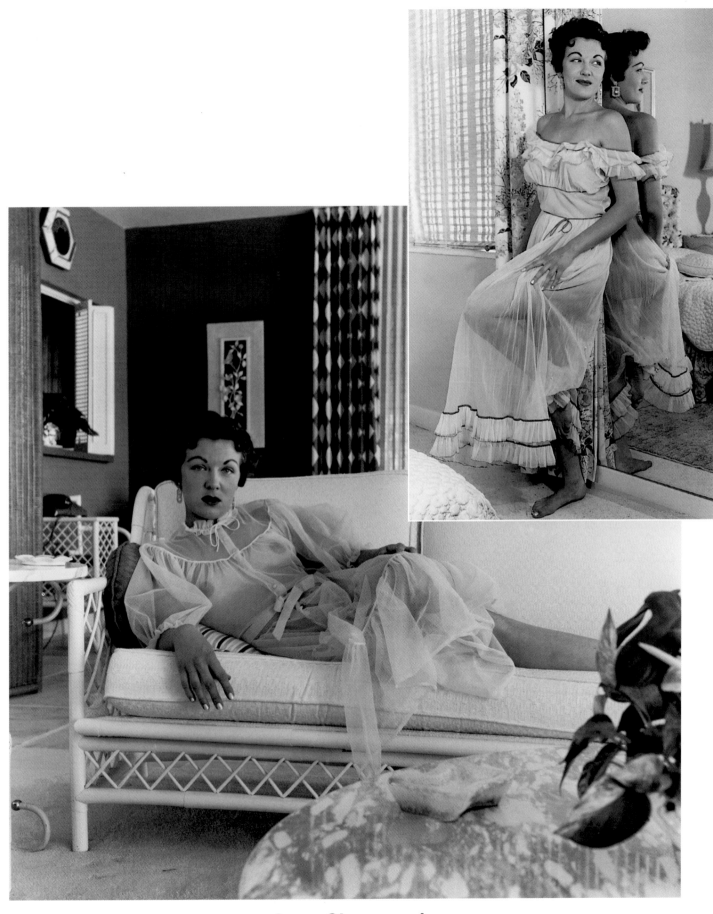

Joan Sherwood

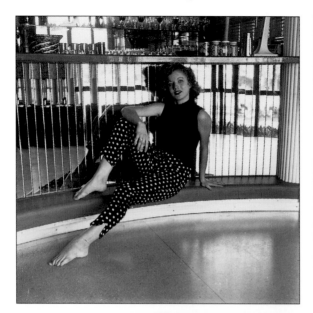 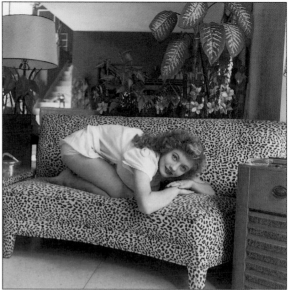

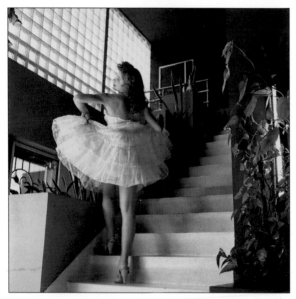 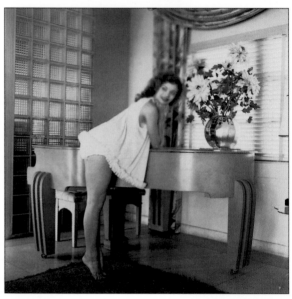

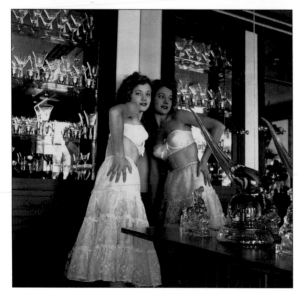 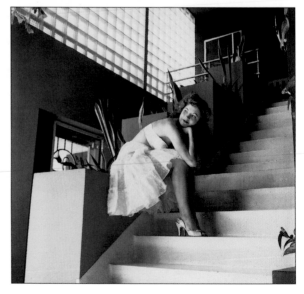

Dolly Murcia

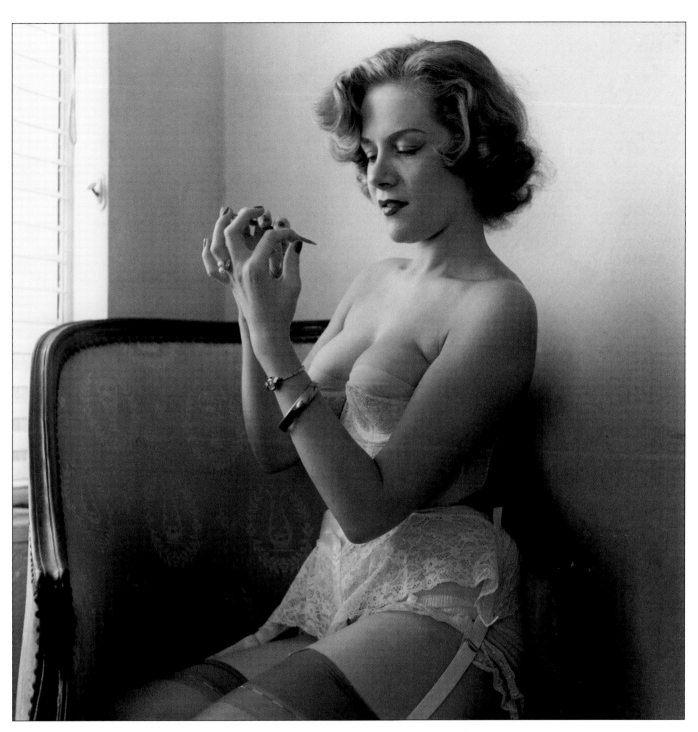

Helene Aimee

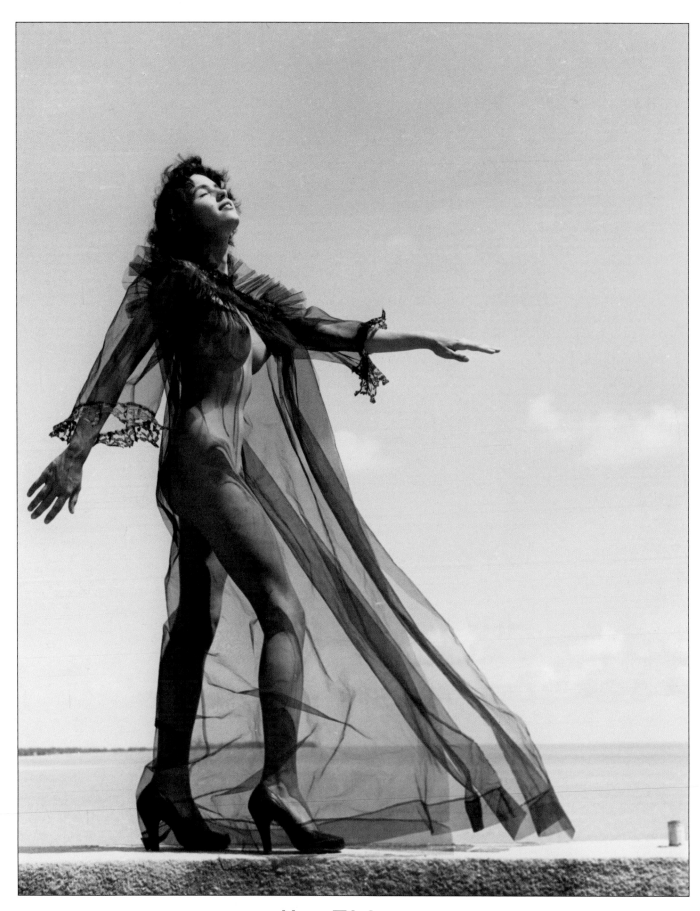

Mary Tilghman

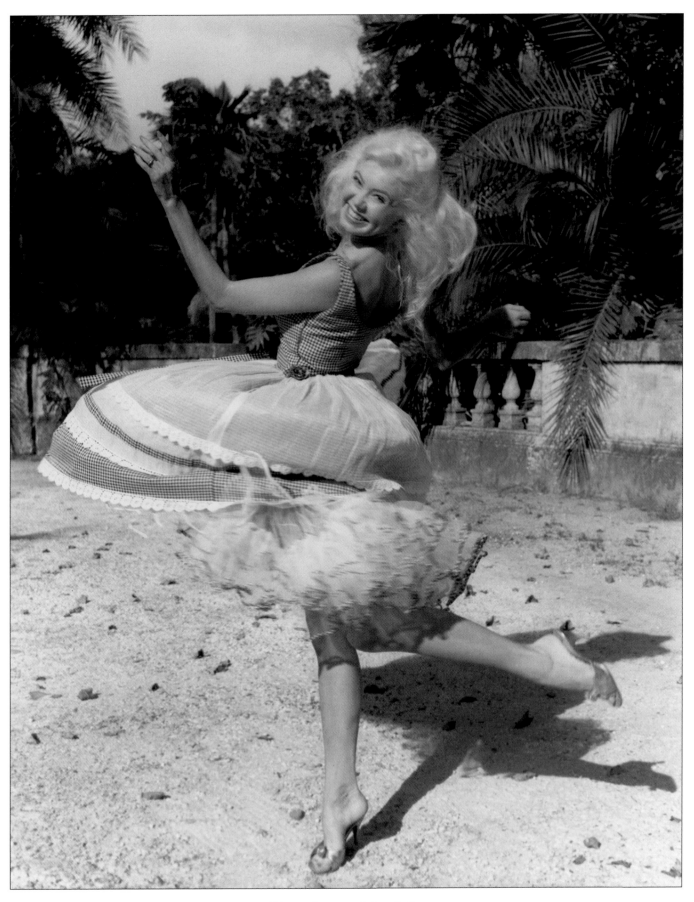

Charlene Mathies

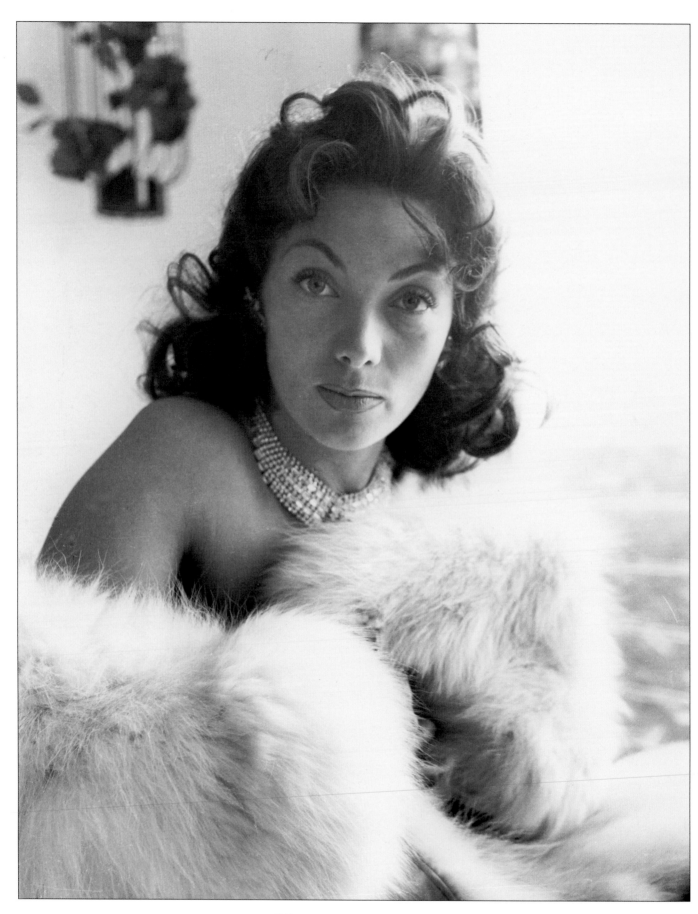

Yvonne Menard

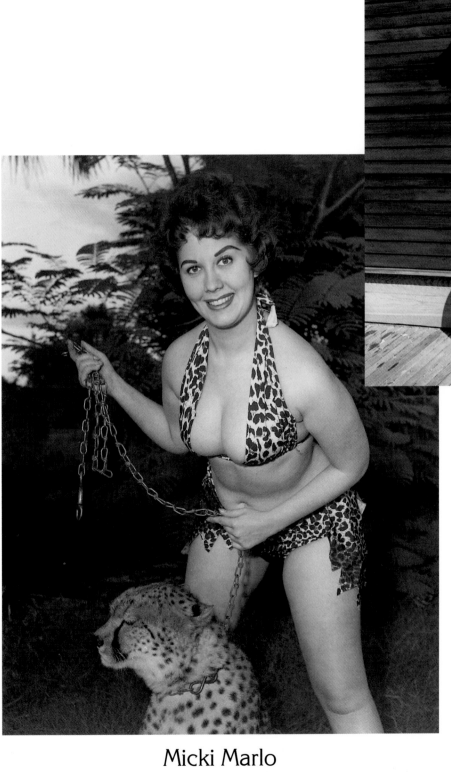

Maritza Antoinette

Micki Marlo

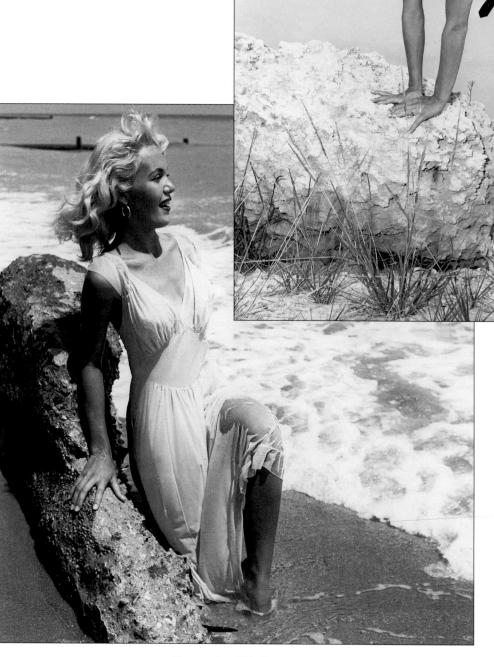

Eleanor Lucky

Sandy Fulton

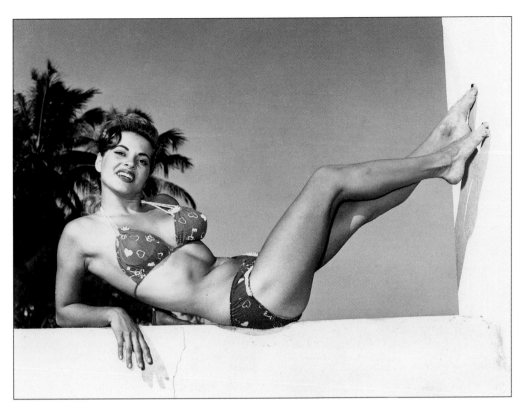

Nanci White

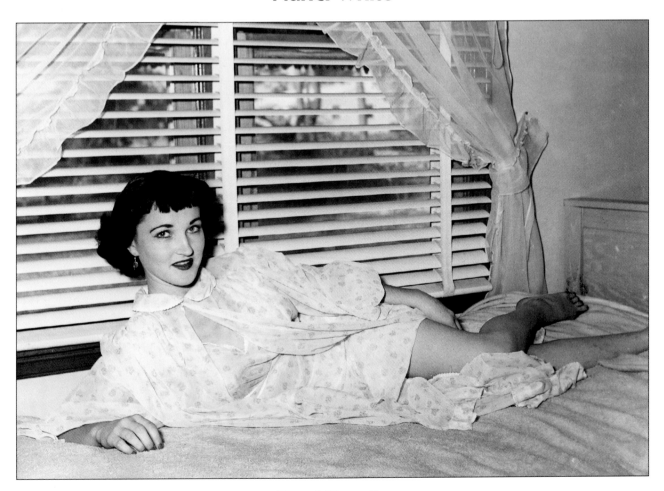

Patti Patelle

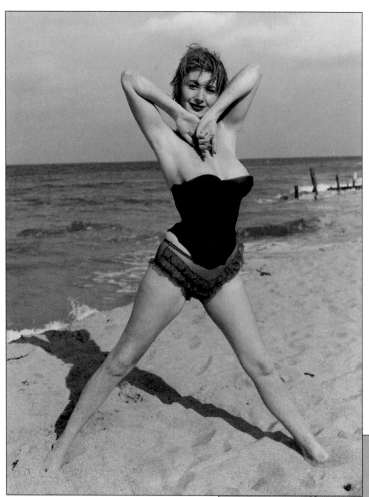

Kevin Cornell

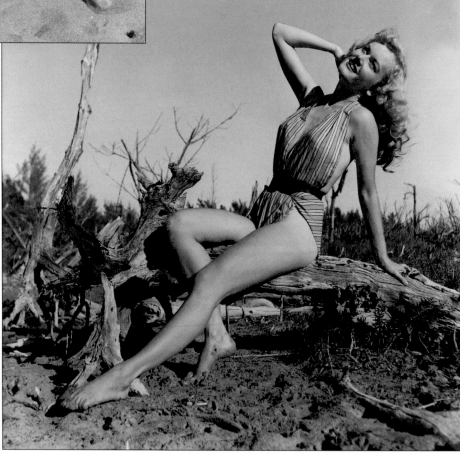

Mary Mills

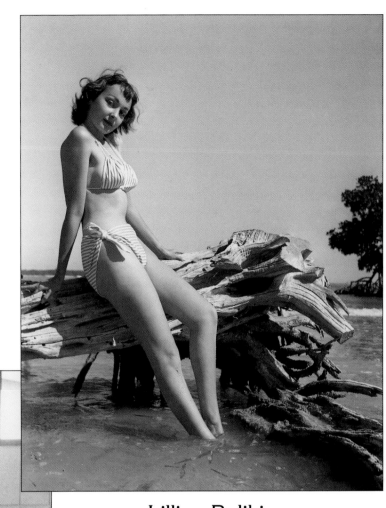

Lillian Balikian

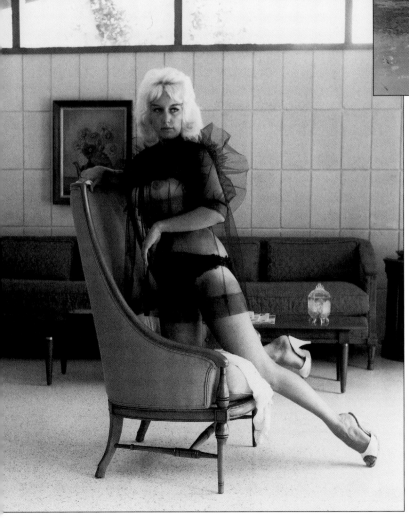

Julia Saxon

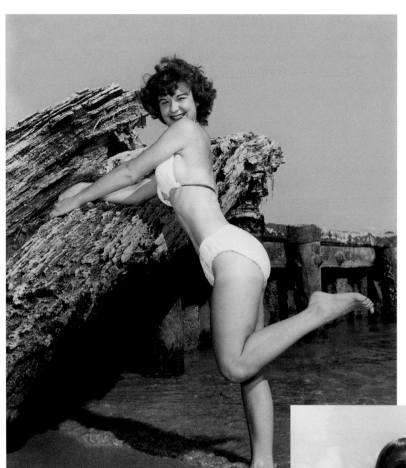

Paula Casey

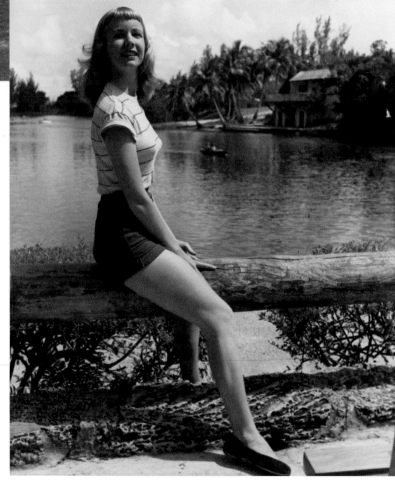

Ann Brockway

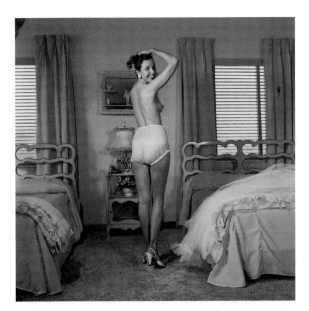
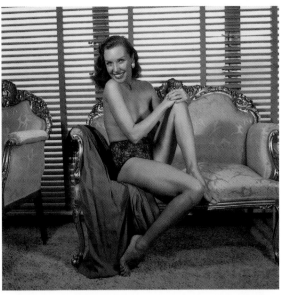
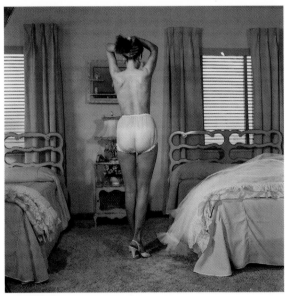
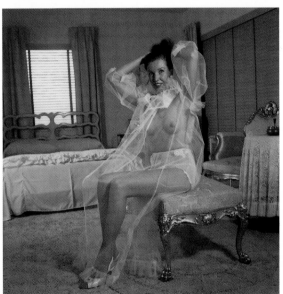
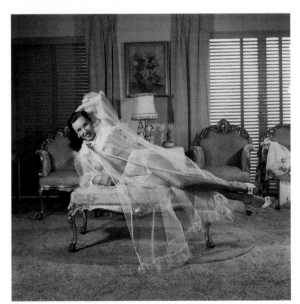
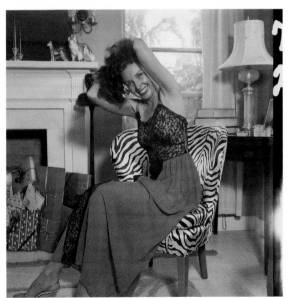

Marge Hershey

107

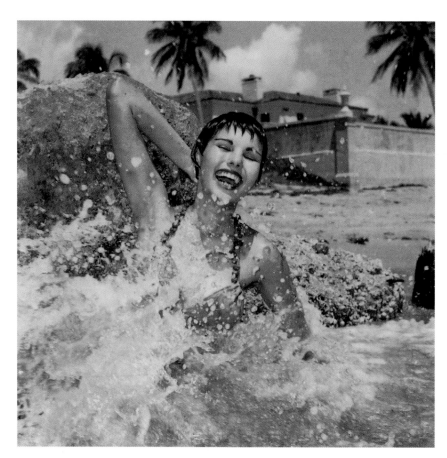

Gigi Reynolds

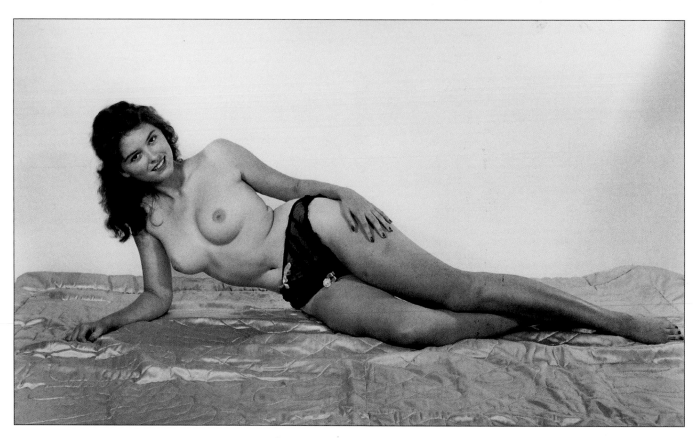

Louise Whitney

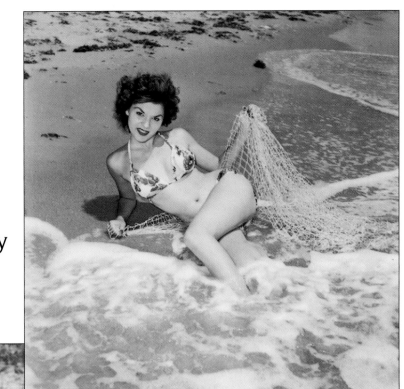

Tina Tiffany

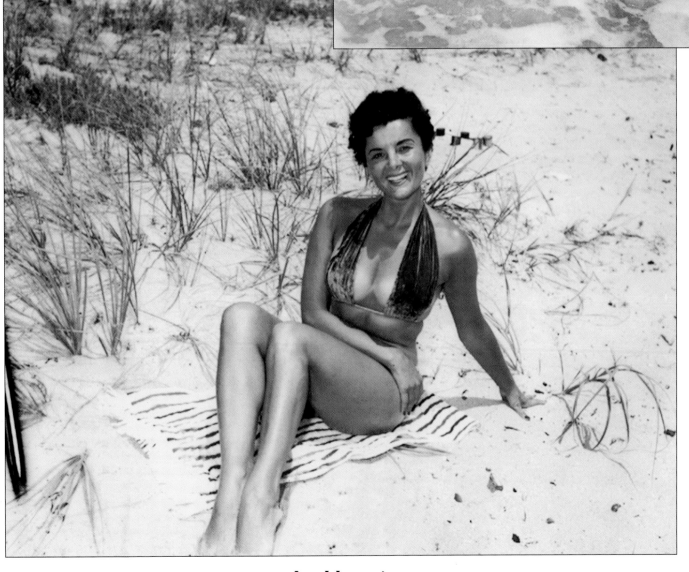

Jet Hamrin

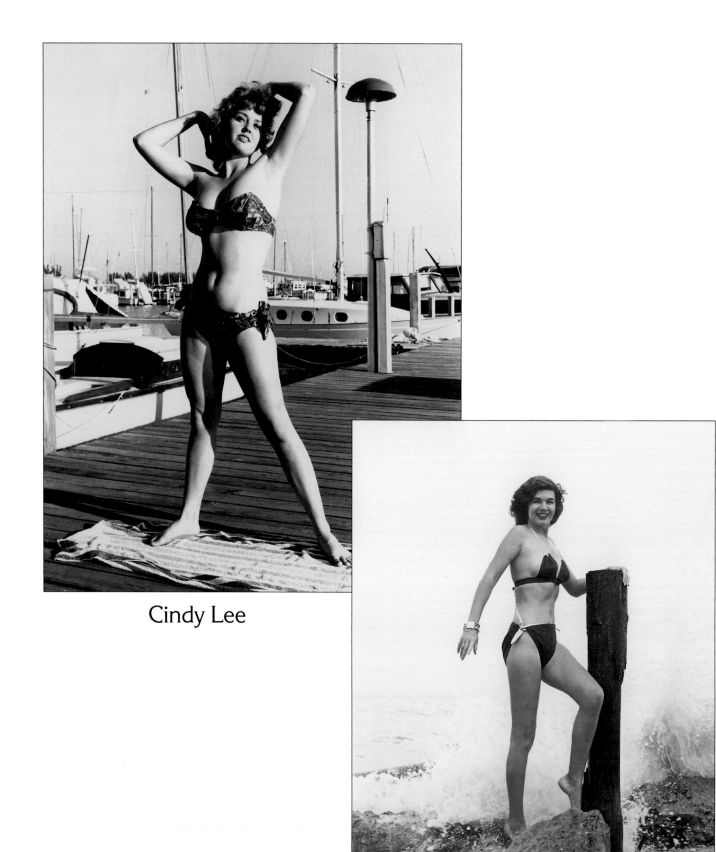

Cindy Lee

Rebel Rawlings

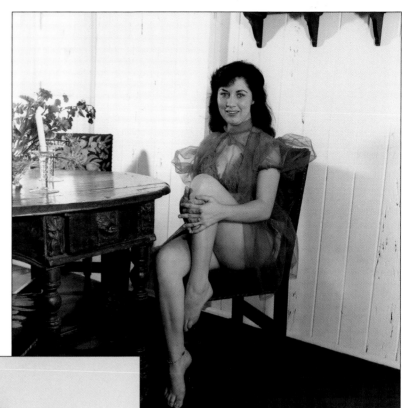

Billie Sue Hunzicker

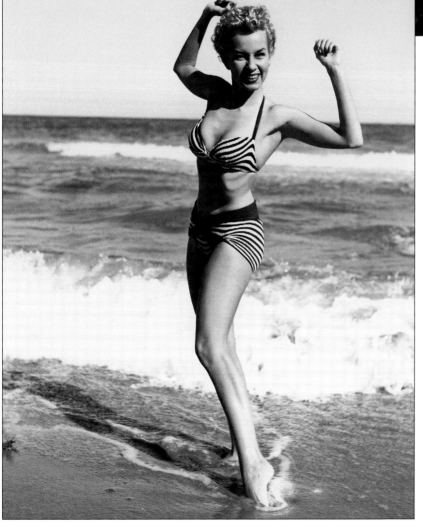

Julie Padilla

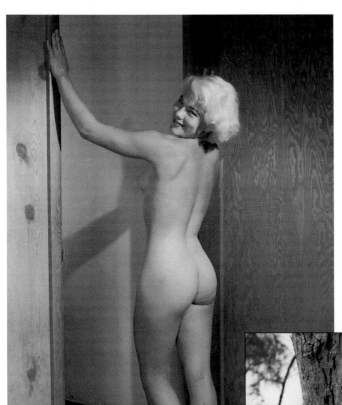

Joyce George

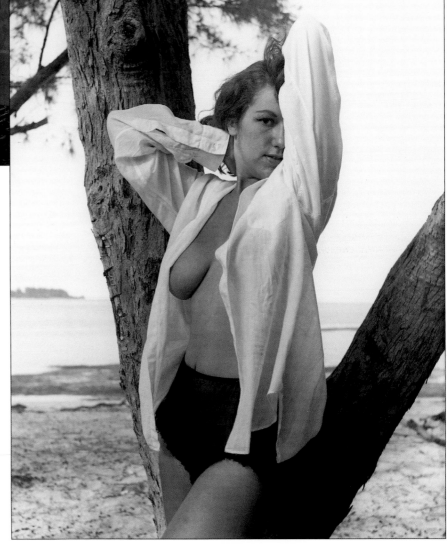

Gloria Sheridan

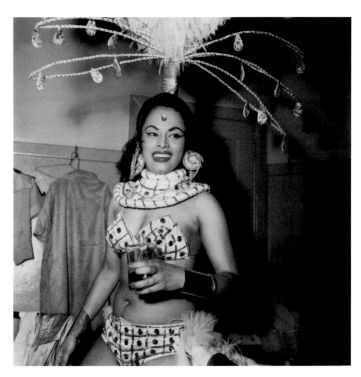

Olga Chaviano

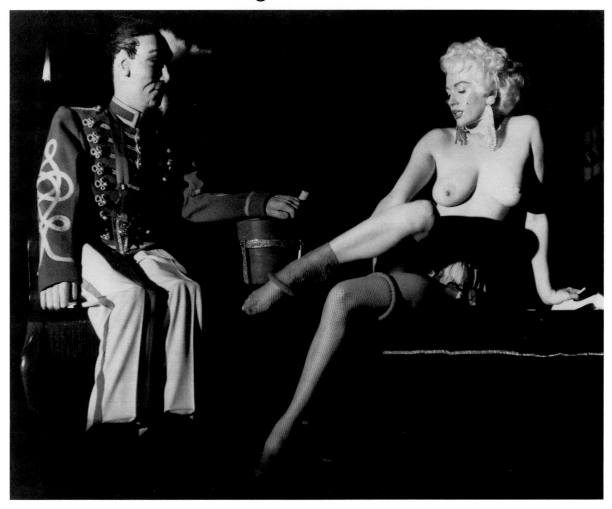

Dixie Evans

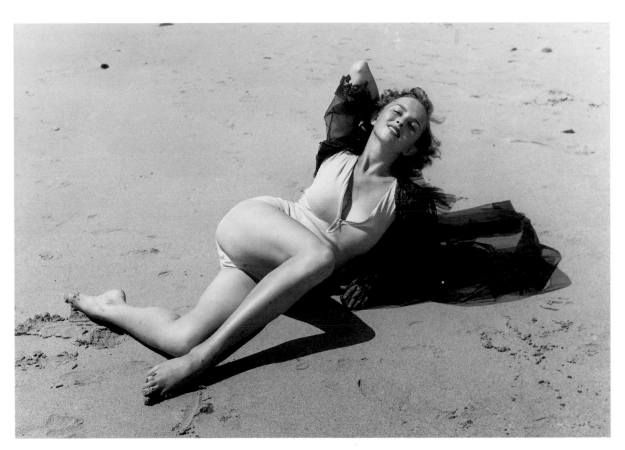

Marcia Valibus

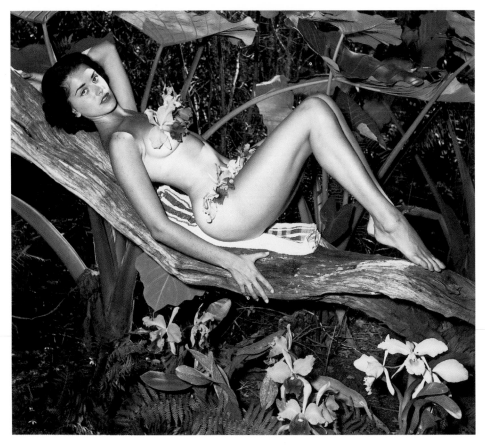

Joan Rawlings

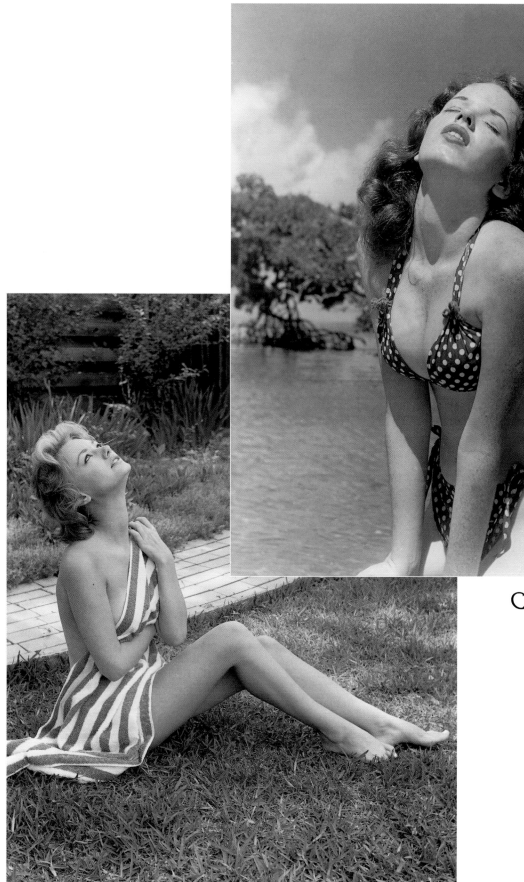

Carolyn Lee

Joan Lamb

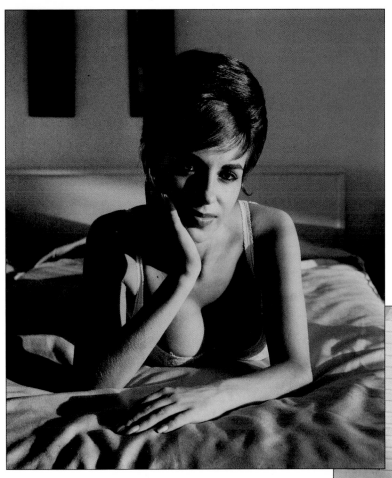

Natalie Tokare

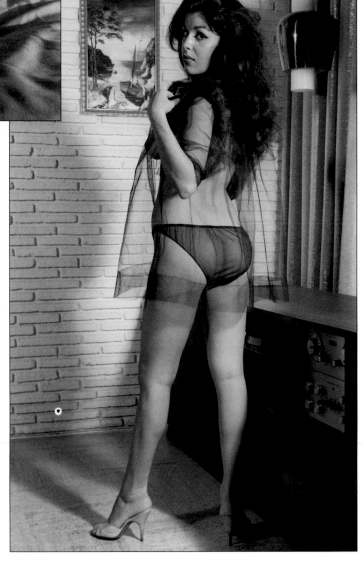

Della Vaughn

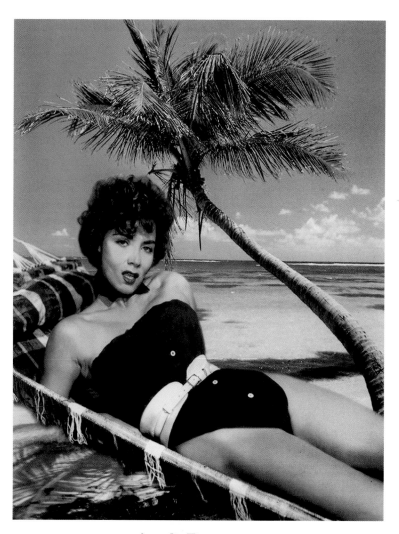

Audi Ragona

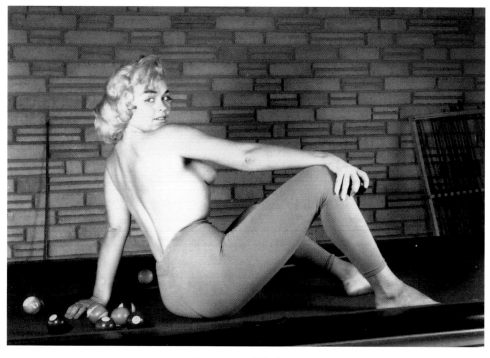

Joyce Miles

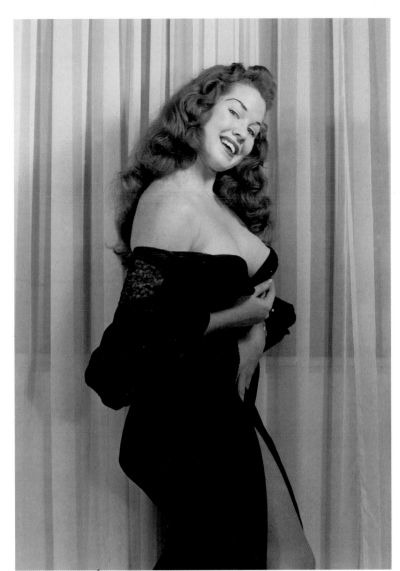

Joy Murphy

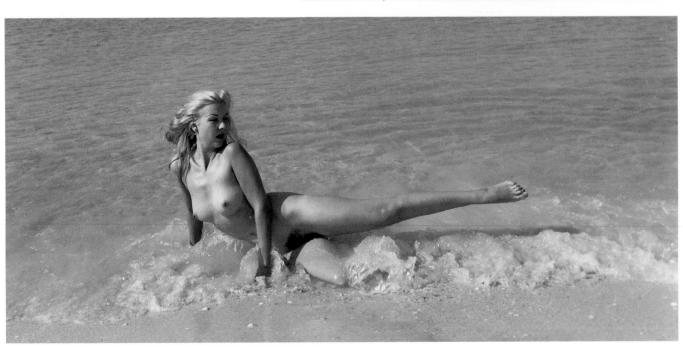

Dottie Sykes

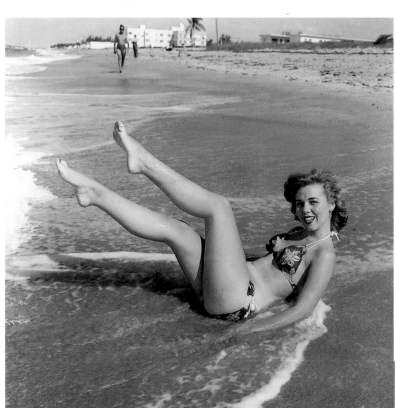

Kelly Evans

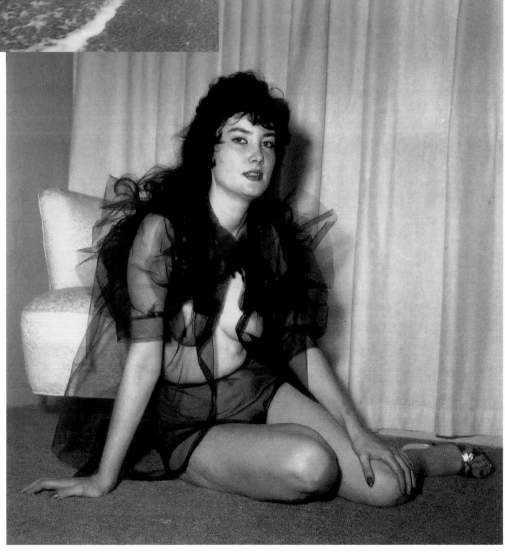

Lynn Tracy

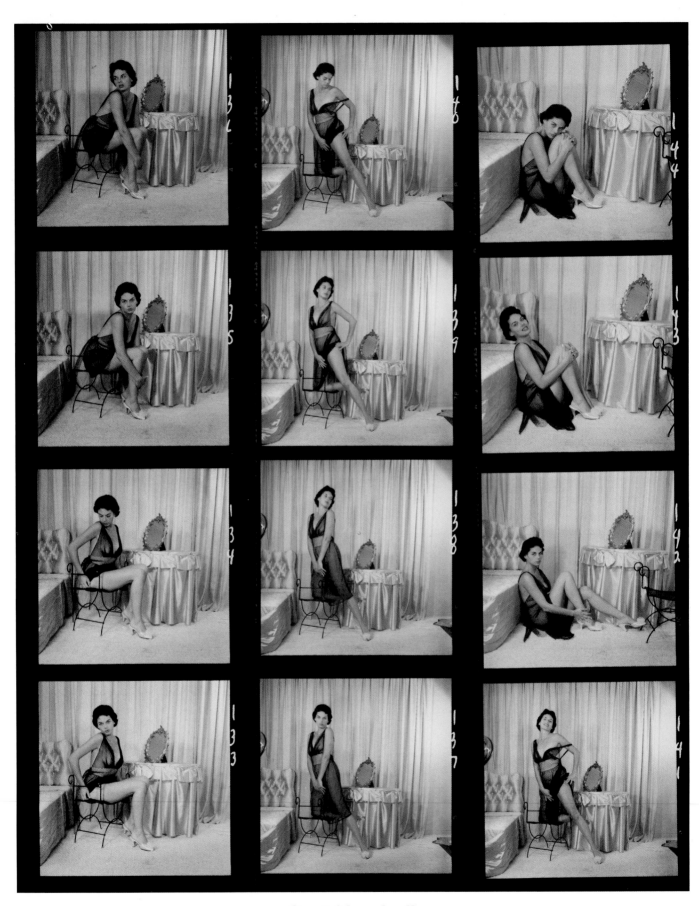

Suzi Marshall

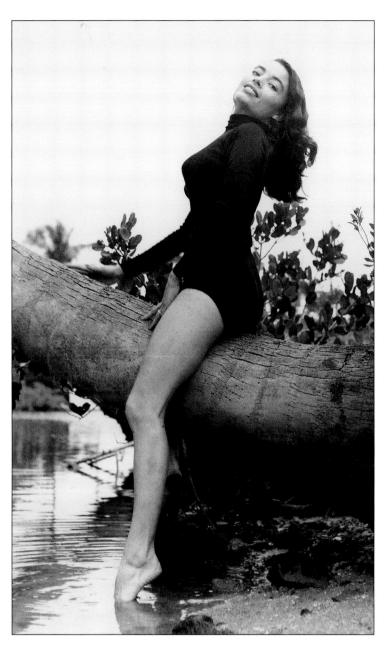

Betty Johnson

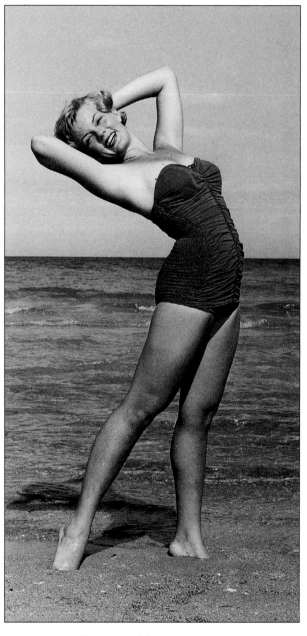

Joan Chewning

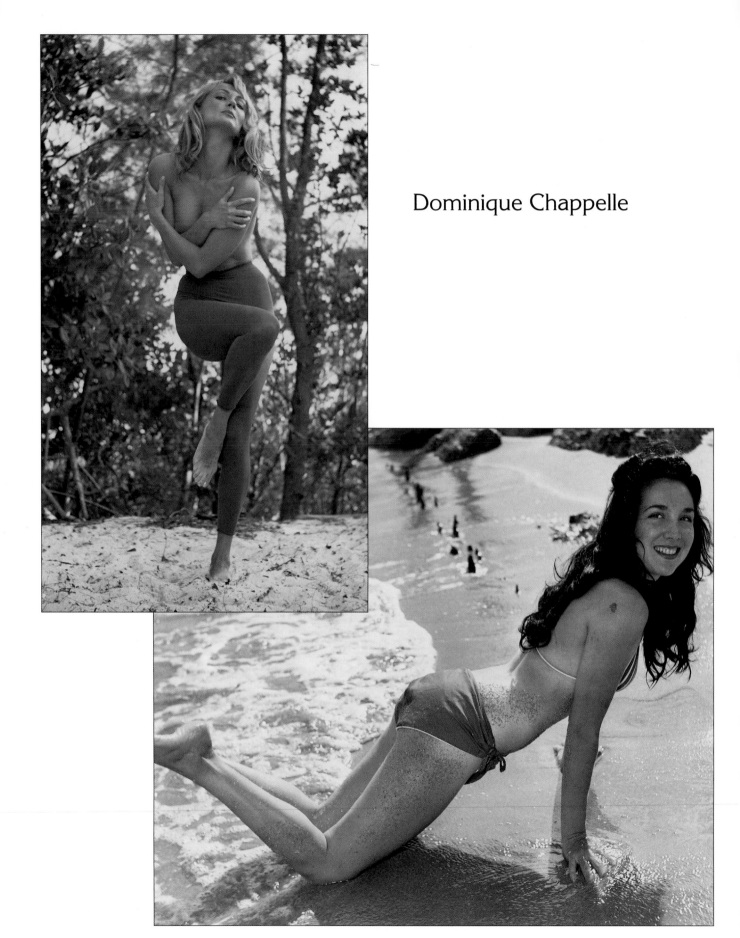

Dominique Chappelle

Camille Stewart

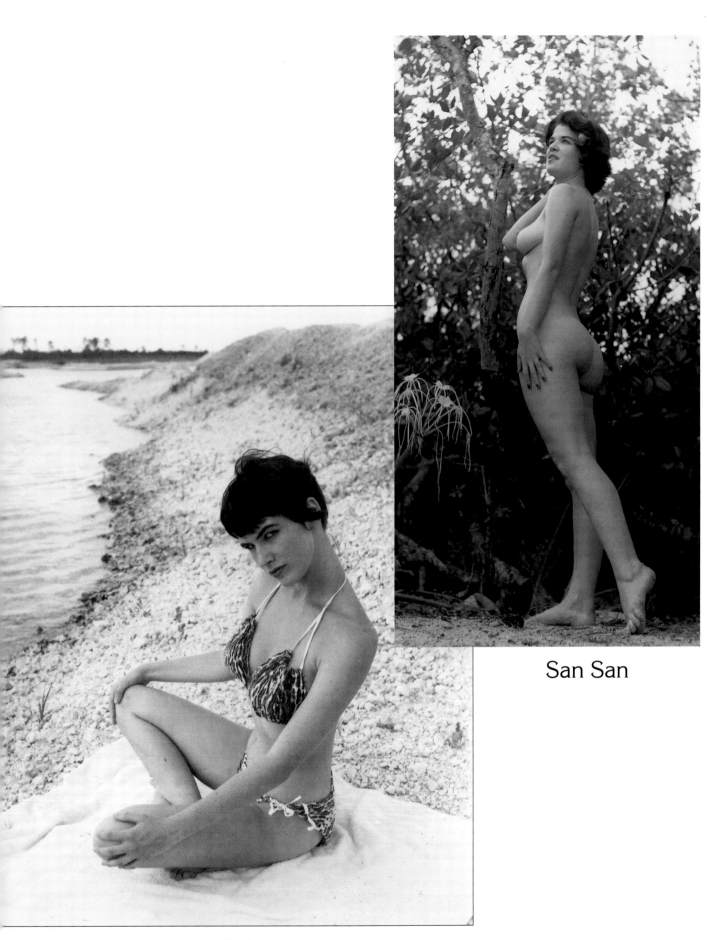

San San

Dondi Penn

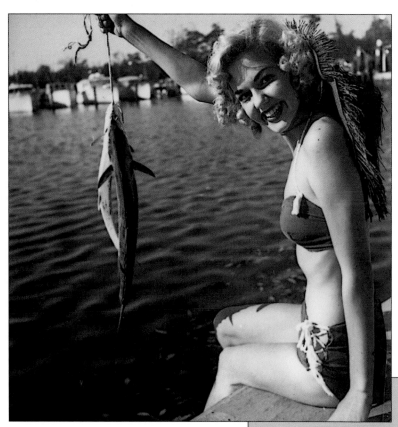

Carol Britt

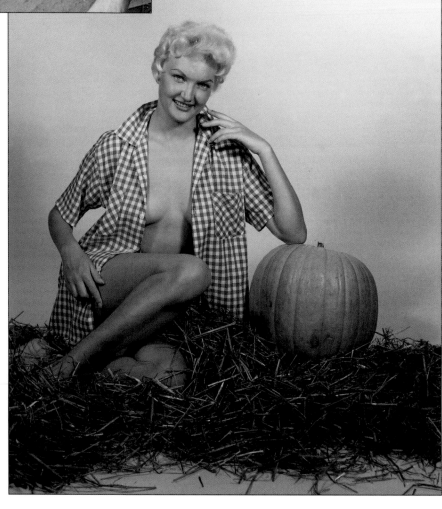

Lillian Bell

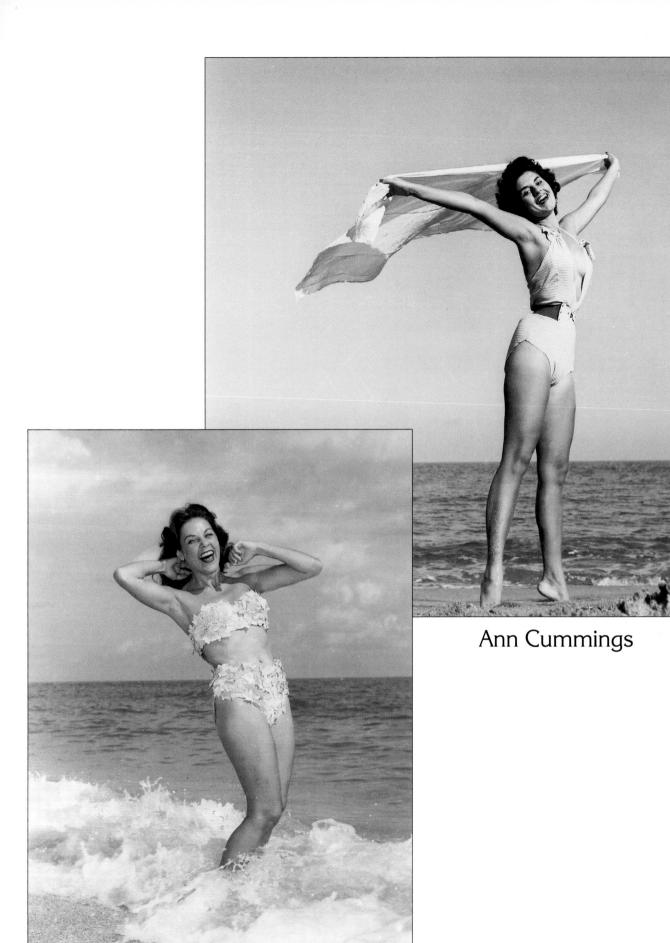

Ann Cummings

Irene Twinam

Bunny Yeager,
Photographer and Model

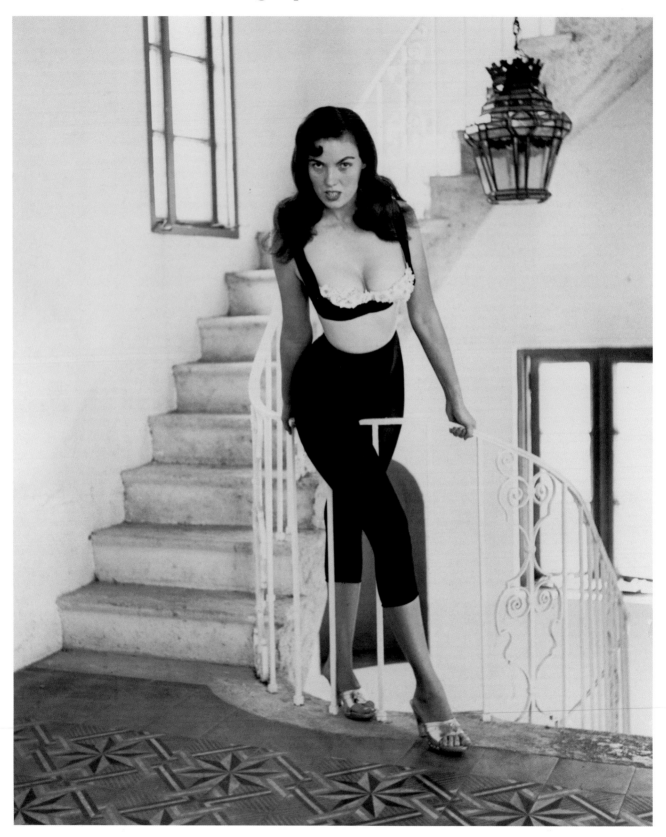

Bunny Yeager

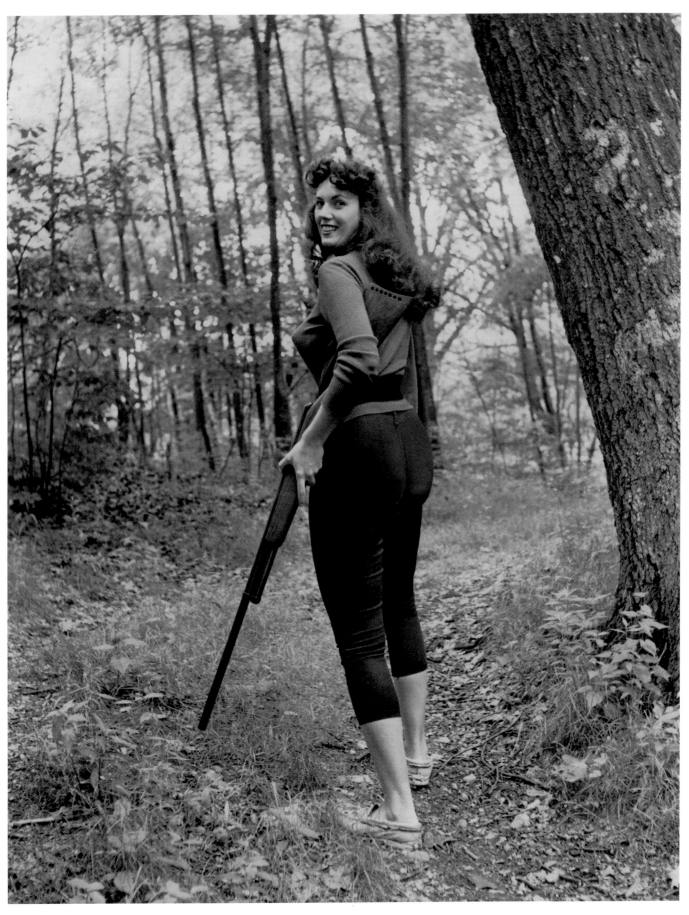

Bunny Yeager

Alphabetical Index